Black Artists in Photography, 1840-1940

Black Artists in Photography, 1840-1940

GEORGE SULLIVAN

ILLUSTRATED WITH PHOTOGRAPHS

COBBLEHILL BOOKS

Dutton New York

PHOTOGRAPH CREDITS

Collection of Anthony Barboza, 13, 16, 60, 73 (bottom); Cincinnati Art Museum, 40; Cincinnati Historical Society, 43; The Historic New Orleans Collection, 19; Historical Society of Saginaw County, 65, 66; Historical Society of Seattle and King County, 56; Hollis Burke Frisell Library, Washington Collection, Tuskegee University, 76, 79, 81; Library of Congress, 10, 35, 36; Louisiana State Museum, 20; Montana Historical Society, Helena, 50, 52, 54, 55; New York Public Library, 45; Public Libraries of Saginaw, Eddy Historical Collection, 64; Schomburg Center for Research in Black Culture, 42, 48, 68 (top), 73 (top), 74, 75, 80; Addison Scurlock, Copyright Scurlock Studio, 84, 88, 90, 92, 93, 94, 97; Robert Scurlock, Copyright Scurlock Studio, 95; Swann Galleries, 2; Swann Galleries, Estate of Randolph Linsley Simpson, 62.

Library of Congress Cataloging-in-Publication Data
Sullivan, George.
Black artists in photography, 1840–1940 / George Sullivan.
p. cm.
Includes bibliographical references and index.
Summary: Surveys the work of African-American professional photographers from the mid-nineteenth to the mid-twentieth century: Jules Lion, Augustus Washington, James P. Ball, the Goodridge Brothers, Cornelius M. Battey, and Addison Scurlock.
ISBN 0-525-65208-6
1. Afro-American photographers—United States—Biography—Juvenile literature. 2. Photography—United States—History—19th century—Juvenile literature. 3. Photography—United States—History—20th century—Juvenile literature. [1. Photographers. 2. Afro-Americans—Biography. 3. Photography—History.] I. Title.
TR139.S85 1996 770'.92'2—dc20 [B] 95-40849 CIP AC

Published in the United States by Cobblehill Books,
an affiliate of Dutton Children's Books,
a division of Penguin Books USA Inc.,
375 Hudson Street, New York, New York 10014

Designed by Mina Greenstein
Printed in the United States of America
First Edition 10 9 8 7 6 5 4 3 2 1

ACKNOWLEDGMENTS

This book would not have been possible were it not for the interest and cooperation of a good number of archivists, historians, collection curators, and librarians, many of whom provided important source material or supplied photographic images. Special thanks are due the following: Robert S. Scurlock, Scurlock Studio; Dr. Daniel Williams, University Archivist, Dr. Xavier Nicholas, and Cynthia Wilson, Tuskegee University; Mary Yearwood, Curator of Prints and Photographs, and Jim Huffman, The Schomburg Center for Research in Black Culture; Carol Johnson, Library of Congress; Deborah Willis, Photo Historian and Collection Coordinator, National African-American Museum; Miles Barth, International Center of Photography; Josephine Harreld Love, Director, Your Heritage House, Inc., Detroit; Daile Kaplan, Head, Department of

Photographs, and Christopher Mahoney, Swann Galleries; John V. Jezierski, Professor of History, Saginaw Valley State College, Saginaw, Michigan; Sandy L. Schwan, Historical Society of Saginaw County, Saginaw, Michigan; Anna Mae Mayday, Hoyt Public Library, Saginaw, Michigan; Evelyn Leasher, Clarke Historical Library, Central Michigan University; Martha H. Smart, Connecticut Historical Society Library and Museum; David O. White, Connecticut Historical Commission; Stephen Rice, Connecticut Historical Society; Lory Morrow, Montana Historical Society; Carolyn Mann, Historical Society of Seattle and King County; Marcia Stein, Washington State Historical Society; Carol Lichtenberg, Washington State University; Claudia K. Kheel and Jeff Rubin, Louisiana State Museum; Jude Solomon, The Historic New Orleans Collection; and Sal Alberti and James Lowe, James Lowe Autographs, New York. Special thanks are also due Tom Mulvaney, East Helena, Montana; Anthony Barboza, Steven Barboza, Allon Schoener, Howard Daitz, Louise Hutchinson, Edwina Harleston Whitlock, and Francesca Kurti, TLC Labs.

CONTENTS

PROLOGUE

On the morning of April 13, 1992, dealers and collectors in antique photographs crowded into the auction room of the Swann Galleries in New York City for the selling of one of the most remarkable early photographs to be seen in years. About 4½ × 5½ inches in size, it depicted a street scene in Cincinnati, Ohio, in about the year 1851. The scene featured a store front with a sign bearing the name MYERS & CO. CONFECTIONERS. A blanketed horse hitched to a wagon stood quietly in front of the store. Workers were loading the wagon.

The photograph was a daguerreotype, a term that refers to an early photographic process in which the image appears on a mirrorlike metal surface, instead of on paper. The photograph was matted, protected with glass, sealed, and then enclosed in a handsome leather case.

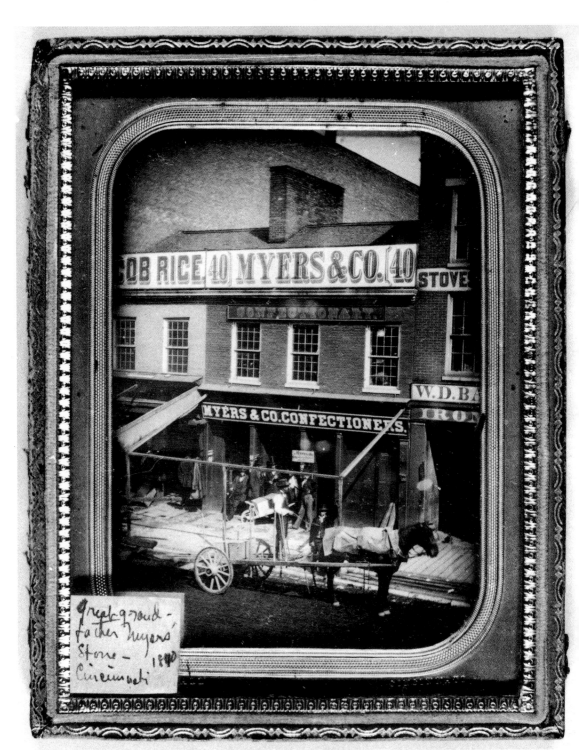

James Presley Ball, a black daguerreotypist, who had opened a portrait studio in Cincinnati in 1847, was the photographer. "J. P. BALL" was stamped on the brass mat. "Street scenes by Ball are very rare," the auction catalog noted.

A handwritten label was attached to the lower left-hand corner of the case that read: "Great grandfather Myers' store, Cincinnati, 1840."

"Daguerreotypes generally have a very special quality but this was truly one of the most stunning images I'd ever seen," said Daile Kaplan, head of the Photography Department at Swann Galleries. "Its great clarity and detail gave the scene a three-dimensional appearance. It jumped out at you! I thought it might bring as much as $20,000 or $30,000."

Bidding was brisk from the beginning and quickly reached $20,000, with three or four bidders interested at that level. When bidding reached $30,000, just two bidders remained, and they continued to slug it out. At $50,000, oohs and aahs could be heard from the audience. The bidding finally stopped at $58,000, a world-record price for a daguerreotype at auction.

Surely, what happened at the Swann Galleries that April morning in 1992 would have astounded James P. Ball himself. In Ball's time, daguerreotype portraits sold for a few dollars apiece. He would have found it incredible that one of his images could cause so much excitement and attract such an awesome price.

A photographer for almost half a century, Ball went about his work each day without ever causing much of a stir. After Cincin-

This daguerreotype by J.P. Ball, depicting a Cincinnati street scene about the year 1851, sold for a record amount in 1992.

nati, he operated studios in Minneapolis; Helena, Montana; and later Seattle. After his death, his work was pretty much forgotten until recent times.

So it was with many other African-American photographers of the late nineteenth and early twentieth centuries. Despite their skill and artistry, and long devotion to their profession, their work has been largely overlooked or simply ignored.

Most books that document the history of photography, even those considered to be the most reliable, make no mention of African-American photographers. It is as if they never existed.

Yet African Americans played a role in photography from the first days the art was practiced in this country. This book profiles several of them: Jules Lion, Augustus Washington, James P. Ball, the Goodridge brothers, Cornelius Battey, and Addison Scurlock. They are among the first and most important African Americans to pursue their craft during the first century of photography's existence.

What was called the "new" art of photography, or at least an early form of it, was born in 1839, the year that Louis J. M. Daguerre's remarkable invention—what he named the "daguerreotype"—was made known to the world. That was some twenty-four years before Abraham Lincoln issued his Emancipation Proclamation, breaking the chains of bondage for the approximately four-million African Americans in the eleven Confederate States of America. They made up nearly one-third of the South's population.

In the Northern states lived some 250,000 "free Negroes." In reality, they were only partly free. They were barred from entering

certain occupations and their movement was restricted. Most worked on farms, or in urban areas, as laborers. Northerners in whose midst they lived often treated them with outright hostility.

It is quite astonishing, then, to realize that there were African-American daguerreotypists who were active from the earliest time in photography's history. Not only did African Americans participate in photography from the very first, they won distinction for their work. In 1856, Glenalvin Goodridge was awarded the prize for the "best Ambrotypes" at the York County (Pennsylvania) fair. (Like the daguerreotype, the ambrotype was another early photographic process.)

Henry Shepherd, the owner of the People's Gallery in St. Paul, was another award winner. He captured a gold medal for photographs he exhibited at the Minnesota State Fair in 1891 and 1892.

In seeking information about early African-American photographers, the most important source is *Black Photographers, 1840-1940, An Illustrated Bio-Bibliography*. Compiled in the early 1980s by Deborah Willis, who, at the time, was a specialist in photographs at the Schomburg Center for Research in Black Culture of the New York Public Library, the book identifies some 65 African-American photographers and lists the books, periodicals, and other writings that relate to each.

Of course, photographs themselves are a vital source in doing research. Photographs of the late 1800s and early 1900s were often mounted on rectangles of stiff cardboard that carried the name and address of the photographer and his or her studio. These card photographs often lead the way to other historical sources.

Newspapers can be helpful. Photographers often placed adver-

tisements in local daily or weekly newspapers. Or the news columns featured articles about their studios or their participation in shows or exhibitions. Census records compiled by the federal government can give valuable information, too.

Historians also rely on city and regional directories. Before the telephone came into widespread use around the turn of the century, the information now supplied by the "phone book" was provided by a city directory or regional directory. Like the modern-day telephone book, these directories presented an alphabetical listing of the residents of the city in a front section. A business directory—similar to today's "Yellow Pages"—was at the back. Nineteenth-century photographers can be found listed in either the alphabetical section or the business section, or both.

Such directories were usually published annually. City libraries and historical societies in most cities usually have copies of such directories.

Information of a more personal nature is sometimes available from letters or diaries. But these are rare.

Information about early black women photographers is even scarcer than what's available about men. While African-American women are believed to have been working in photography during the 1860s, none of their photographs are known to have survived.

A good chunk of what is known about African-American women and their role in photography is the result of research undertaken by Jeanne Moutoussamy-Ashe for her book, *Viewfinders, Black Women Photographers*, published in 1986. She cites Mary E. Warren of Houston, Texas, as one of the very first black women involved in photography in the United States. She is listed in the Houston

city directory for the year 1866, according to Jeanne Moutoussamy-Ashe. Warren's occupation is given as a "photograph printer." Next to her name appears the abbreviation "col.," for colored.

Moutoussamy-Ashe called Mary Warren "an unusual person." And she was. "She was a Southern black woman, working in a profession unusual for blacks or whites, male or female, in an unusually conservative and prejudiced part of America." Not Moutoussamy-Ashe or anyone else has been able to discover a Mary Warren photograph.

The role of countless black women in photography has never been fully documented. That's because they often worked as assistants to their husbands. While they frequently made enormous contributions in helping their husbands achieve business success, they were usually "silent partners."

Take, for example, the Harleston Studio, opened in Charleston, South Carolina, in the spring of 1922 by Edwin and Elise Harleston. It was actually two studios—a painting studio operated by Edwin and a photography studio operated by Elise.

Elise was very well schooled in photography. She attended the E. Brunel School of Photography in New York City (where she was one of only two blacks in her class and the only woman). After that, she enrolled at Tuskegee Institute to take an advanced course in photography taught by Cornelius Battey.

Once the Harlestons opened their studio, Edwin rendered portraits in charcoal, crayon, or oil. Sometimes he would have Elise photograph his subjects and then he would work directly from her photographs as he painted. This made it easier for the subject, who would not have to pose, sitting virtually motionless for hours.

Edwin Harleston died in 1921. In the years since, he has been enthusiastically acclaimed as a painter, a muralist, and a pioneer in African-American portraiture. Elise's photographs have barely been acknowledged.

During the late 1920s until the early 1940s, a number of black photographers—*male* photographers—benefited from the efforts of the Harmon Foundation, which was established with the idea of "acquainting and interesting the public in the fine arts, by Negroes, and encouraging the Negro endowed with high creative ability to give wide expression to his genius."

Photographers who participated in competitions and exhibitions arranged by the Harmon Foundation included James Latimer Allen, Edgar Eugene Phipps, Taylor Kelley, and King Daniel Ganaway. Ganaway is especially interesting. After arriving in Chicago in 1914, he worked as a butler for one of the city's wealthiest families. Little by little, he became interested in photography and eventually began working as a photographer on his days off from his regular job. Ganaway's work was shown by the Harmon Foundation and in 1918 he won first prize in the John Wanamaker Annual Exhibition that attracted more than 900 entries.

An article by Edith Lloyd in the *American* magazine in March, 1925, titled "This Negro Butler Has Become a Famous Photographer," described Ganaway's special flair: "He can take a massive grain elevator, or a murky stretch of river, and by softening his focus, produce the effect of a beautiful soft etching. His talent seems to be in discovering the romantic aspects of commonplace things . . ." Sadly, no original Ganaway negatives or prints are known to exist.

During the 1920s and a period known as the Harlem Renaissance, black art flourished. An incredible amount of black literature was produced by such writers as James Weldon Johnson, Langston Hughes, Claude McKay, and Countee Cullen. The black theatre made progress, too.

Black photographers of the time included Addison Scurlock in Washington and James Van Der Zee in New York. Van Der Zee had been a musician and a painter. His wife convinced him to open a photograph studio. For the next half century, he used his camera to document the life and spirit of Harlem. No other black photographer is as well known as James Van Der Zee. His work was spotlighted in 1969 when the Metropolitan Museum of Art presented an exhibition titled "Harlem on My Mind: Cultural Capital of Black America, 1900-1968." Van Der Zee died in 1983.

Gordon Parks and Roy DeCarava are among the most noted African-American photographers of recent decades. Parks was called "a journalist with a camera." Certainly he fit that description when he worked in the photographic section of the Farm Security Administration and later for *Life* magazine, producing black-and-white documentary images. But Parks was much more than a photojournalist. He was a motion picture director, a composer of orchestral music, a novelist, poet, and the author of no fewer than four autobiographies. An exhibition of his "landscape" photos, produced from tabletop scenes that he created in his own home and photographed with a close-up lens, opened in New York in 1994. Parks turned eighty-one that year.

Like Parks, Roy DeCarava was an important influence. This resulted from his commitment to document and interpret the

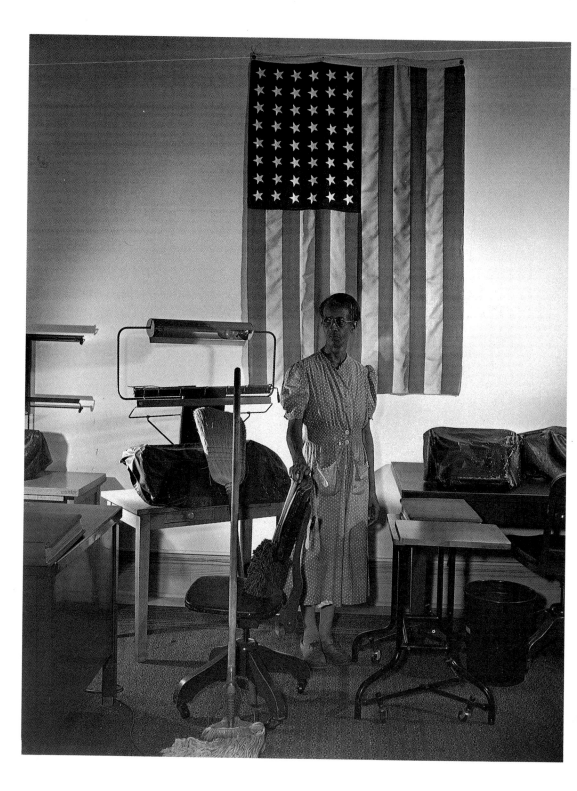

African-American urban experience. "Strength," "pride," and "ex-
traordinary toughness" were terms that were used to describe his
work.

In 1963, Roy DeCarava served as an adviser to several other black
photographers who started the Kamoinge Workshop to provide ar-
tistic support and inspiration for its members. (*Kamoinge* is a Kikuyu
word for a "group of people working together.") Their goal was
to address in photographic terms what it means to be black in
America.

The Kamoinge Workshop had its own gallery in Harlem and
organized and participated in photographic exhibits, among its other
activities. Its members made a major contribution toward the cul-
tural development of the period and helped to influence the artistic
growth of younger photographers. Members are still a closely knit
group, but the Workshop no longer exists on a formal basis.

In 1978, a number of members of the Kamoinge Workshop
joined together to found the International Black Photographers.
Like Kamoinge, its goal was to present exhibitions and win rec-
ognition for black photographers. The IBP sought to establish a
gallery to display the work of black photographers and an archive
to present the visual and oral history of African-American photo-
graphic art.

Nowadays, group exhibitions by black photographers are pre-
sented with some frequency. Some of the more important have
included the Smithsonian Institution's exhibition titled "We'll

*As a documentary photographer, Gordon Parks had few equals. This photograph,
which dates to the early 1940s, depicts a government charwoman.*

Never Turn Back." Devoted to civil rights photographs, the exhibition was first shown at the Smithsonian's National Museum of History and Technology in 1980. The Rhode Island School of Design offered "A Century of Black Photographers: 1840–1960" in 1982. "Imagining Families: Images and Voices," which opened in 1994, was the first exhibition organized by the National African-American Museum Project of the Smithsonian Institution.

Anthony Barboza is one of the most original black photographers working today. Born in New Bedford, Massachusetts, in 1944, Barboza learned fashion photography from Hugh Bell and through his membership in Kamoinge. "But I owe more to street photography than any other kind," Barboza, who now maintains a studio in New York, has said. "Being out on the street, seeing and watching and being aware, sharpens your eye."

One of the founders of International Black Photographers, Barboza has achieved success both as a fashion and advertising photographer. He is well known for his street life photographs and portraits of a wide range of notables, everyone from Marvin Hagler, the boxing champion, to poet Ntozake Shange.

Barboza is unique because of his deeply rooted interest in the first African-American photographers. He has been collecting their work since the early 1970s. "Painter Romare Bearden was the one who got me interested in them," Barboza says. "He told me about people such as Ball and Washington.

"I wanted to find out more about them but there was no place to go. I would call up museums, dealers, and collectors who had daguerreotypes and ask them if they had any photographs by these names, and they'd ask why I wanted to know. As soon as it got out that I was interested in black photographers, they started raising

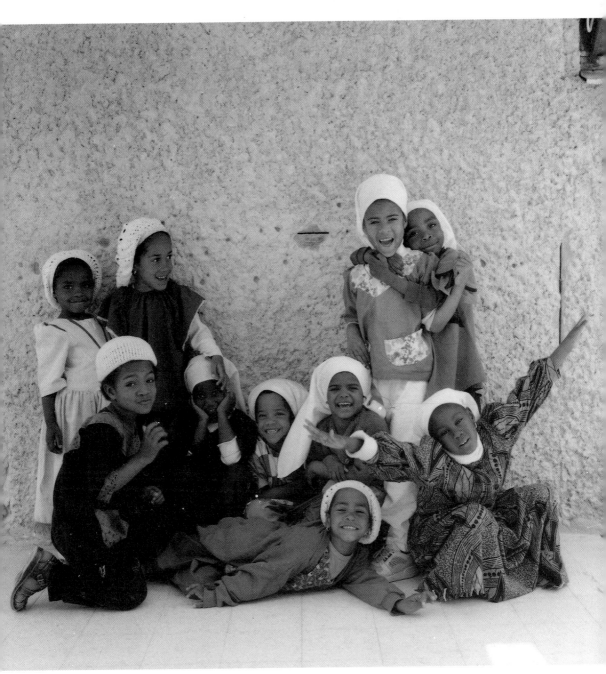

Anthony Barboza photographed these black Hebrew children in Israel in 1994.

their prices for their photographs. After that, I wouldn't tell anybody.

"As far as daguerreotypes are concerned, I have a lot of them, maybe twenty-five," Barboza continues. "I have some by Ball, Washington, and the Goodridges, and they are very hard to find.

"Washington was the first one with a studio who provided special clothes for people who came in for a shooting. Before anybody. In all of his photographs, the people had on black clothes. It's interesting.

"I have the names of many other early black photographers but it's hard to find examples of their work. For instance, Mathew Brady, the Civil War photographer, had a black assistant. But very little is known about him. And I haven't been able to find any of his photographs. The same is true with several others. There's a lot more work to be done."

It's true. Much more remains to be discovered and written about the first African-American photographers. It would be nice if this book helped to encourage that effort.

ONE

Jules Lion

Jules Lion, a free man of color, was one of the nation's first photographers, black or white. Lion, who came to the United States from France in 1836 or 1837, is likely to have brought with him the knowledge of how to make a daguerreotype, the early photographic process that was developed in France and introduced to the world in 1839.

Sadly, there is only one photographic image of Lion's known to exist, and that is in the hands of a New York collector. All the others have been lost or destroyed. However, the Historic New Orleans Collection, a museum and research center, and the State Museum of Louisiana have managed to preserve examples of Lion's paintings, drawings, and lithographs. One of these, a lithographic print depicting the St. Louis Cathedral in New Orleans as it looked

in 1840, is believed to have been made from one of Lion's daguerreotypes.

Jules Lion was born in France sometime between 1810 and 1816. A successful portrait painter by the age of seventeen, Lion (pronounced lee-*own*), was also a lithographer, creating images on specially prepared flat stones or metal plates. After the stone or plate bearing the image had been properly inked, multiple copies of the image could be printed from it.

Lion exhibited his lithographs at the Exposition of Paris in 1833. One of them, titled *"Affut aux Canards"* ("The Duck Blind"), won honorable mention.

As a Frenchman with a professional link to image-making, Lion surely knew of the important experiments in photography that were taking place during the early decades of the nineteeth century. In 1826 or 1827, Joseph Nicéphore Niépce, a Frenchman, produced what is now looked upon as the world's first photograph, an image of a pigeon house and barn made from the window of his home. Niépce called his images "heliographs," from the Greek "helio," for sun, and "graph," meaning drawn or written.

Niépce talked with Louis J. M. Daguerre about his invention. Daguerre was a French artist and the operator of the Paris Diorama, an elaborate theatrical spectacle that presented huge painted scenes illuminated by changing light sources. Daguerre thought the work that Niépce was doing might somehow be useful to the Diorama.

In 1829, Niépce and Daguerre signed a ten-year contract that

This rare tintype depicts an unidentified black man. Some sources say it may be Jules Lion himself.

provided for the development of a more efficient photographic process. But Niépce died in 1833, before his partnership with Daguerre had achieved its goal. Daguerre continued to experiment, with assistance from Isidore Niépce, Joseph's son.

Four years after Niépce's death, Daguerre perfected a photographic process that involved treating a thin sheet of silver-plated copper with fumes from heated crystals of iodine. This made the silver-coated copper plate sensitive to light. The small plate was then placed in a camera and exposed to light for a period of from five to forty minutes. The next step was to remove the silvered plate from the camera and develop it, accomplished by placing it in a holder and suspending it over a dish of heated mercury. The mercury vapor combined with the silver to form a finely detailed image. Isidore Niépce allowed Daguerre to call his discovery the daguerreotype.

In 1839, the French government announced Daguerre's invention to the world. By the next year, instruction manuals describing the daguerreotype process were available in eight languages and other inventors were working on improvements to the process.

Americans began experimenting with daguerreotypes in 1839. In November of that year, François Gourand, a student of Daguerre's who also acted as his personal agent, arrived in New York. In the months that followed, he demonstrated the daguerreotype process in a number of American cities. He also sold instruction books and cameras.

By this time, Jules Lion had immigrated to the United States from his native France and settled in New Orleans. His name first appears in the New Orleans city directory in 1837. He is listed as a painter. In 1838, the listing added " . . . and lithographic portraits."

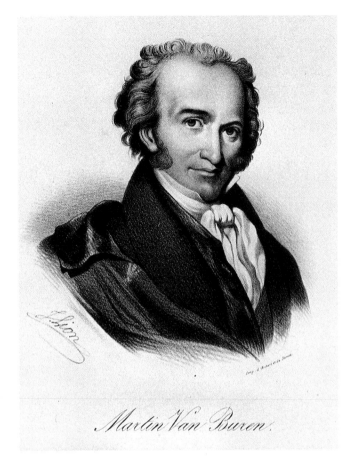

Lion's lithographic portrait of Martin Van Buren,
eighth President of the United States.

As early as 1840, Lion had established himself as a professional daguerreotypist. On March 13 of that year, an article in *The New Orleans Courier* announced that "on Sunday next, 15th March, at 11 o'clock precisely, he [Mr. J. Lion] will give, in the Hall of St. Charles Museum, opposite the St. Charles Hotel, a public exhibition, in which shall be seen the likeness of the most remarkable monuments and landscapes existing in New Orleans . . ."

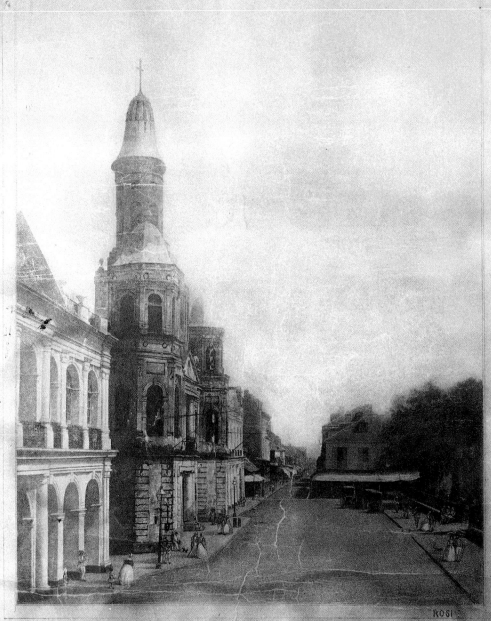

DESSINÉ PAR J.LION. LITH.

ROSI

LA CATHEDRALE THE CATHEDRAL

New Orleans

1842

As a rule, early American daguerreotypists concentrated on portrait photographs. Landscape or architectural views were uncommon. In Europe, it was otherwise, however. As William Welling points out in *Photography in America, The Formative Years, 1839–1900*, daguerreotypists recorded scenic views in France, Italy, Spain, Greece, Egypt, and several other countries.

So it was that Lion, with his European training, photographed the architecture of New Orleans—the St. Charles Hotel, Royal Street, the Town House, and the aforementioned St. Louis Cathedral.

As of 1995, only one of Lion's photographic images was known to have been preserved, and that is a tintype. In the tintype, a negative was produced, not on a silvered plate of copper as in the case of the daguerreotype, but on a blackened sheet of thin iron. (Since the tintype was actually iron, not tin, it was misnamed.) Inexpensive to produce, the tintype was sometimes called "the poor man's daguerreotype."

The Lion tintype, which dates to about 1850, depicts an unidentified black man. Some sources claim that the man may be Lion himself.

At least two New Orleans cultural institutions own lithographs of Lion's. One of these depicts the St. Louis Cathedral in New Orleans as it looked in 1841. It is believed that Lion made this lithograph from one of his daguerreotypes.

Lion was described as "an artist of superior merit" in an article

Lion's lithograph of the St. Louis Cathedral on Chartres Street in New Orleans is believed to have been based on one of his earliest daguerreotypes.

in *The New Orleans Bee* on November 25, 1843. "His Daguerreo-type impressions are . . . very fine, and he possesses the art of coloring them—a process by which faintness of outline, which has been considered the chief objection to the Daguerreotype, is made to give a strong, bold and desirable impression."

After 1843, Lion stopped advertising his services as a daguerreo-typist, apparently to concentrate on portrait painting and to teach. In 1848, he and Dominique Canova opened an Academy of Paint-ing and Drawing in New Orleans. And by 1852, Lion had become a professor of drawing at Louisiana College, also in New Orleans. Four years later, Lion was advertising he had lithographed portraits of former president Millard Fillmore for sale. Lion concentrated on a life as a "quiet" professor of drawing at Louisiana College until his death in 1866.

Most accounts of Jules Lion's life credit him with being "the photographer who introduced the daguerreotype to the city of New Orleans." But Lion was much more. In 1840, the year that the foundations for photography were being laid in America, Jules Lion was in the forefront in helping to establish the process as both an art and a business enterprise.

TWO

Augustus Washington

From his earliest days, young Augustus Washington had the ambition "to become a scholar, a teacher, and useful man." By the time he had reached his mid-twenties, he had achieved his goals.

But despite his success in educating himself and establishing and operating one of New England's first daguerreotype studios—the very first in Hartford, Connecticut—Washington felt unfulfilled because of the injustices that he and other black Americans were made to face. In the years before the Civil War, Washington spoke out against the "servile and degraded condition" of African Americans. He came to believe that only in Africa could a black man " . . . find a home on earth."

Washington did more than simply speak his mind; he took action. In 1854, he left the United States for the African colony of

Liberia. At first, he worked as a photographer, but later became a successful farmer. In 1855, he told a visiting friend that he was "perfectly satisfied" with Liberia. He and his family are believed to have spent the rest of their lives there.

Augustus Washington was born in New York City in 1820 or 1821. Little is known of his parents, except that his mother was Asian and his father had been a slave in Virginia. Augustus was well educated as a young boy, receiving a schooling that was equal to that of white children of the day.

By the time he had reached his mid-teens, Washington, who had been deeply influenced by reading antislavery publications and attending abolitionist meetings, had become seriously concerned about slavery in the South and discrimination in the North. He began to think of ways that he could "best contribute to elevate the social and political position of the oppressed and unfortunate people with whom I am identified."

He realized that education was a key factor. At the age of sixteen, Washington opened his own school for blacks. Within five months, however, he became discouraged because he was able to accomplish so little, and closed the school. He then decided to improve his own education and began applying to those few colleges that then accepted black students.

Washington was accepted at Oneida Institute in Whitestown, New York, and entered the school in the late 1830s. Money, or the lack of it, became a serious problem. His bills kept mounting and his father refused to pay any of them. Washington had to quit school and find work.

The job he found was as a teacher in a public school in Brooklyn,

New York. He proved so effective that he was offered a raise in pay of $100 a year. But Washington turned down the salary increase to return to school himself, entering Kimball Union Academy in Meriden, New Hampshire.

Washington did not stay at Kimball very long, leaving in 1843 to enter Dartmouth College in Hanover, New Hampshire. Again he had financial problems. His parents refused to help him because, as Washington was later to note, they considered studying to be a waste of time.

It was during this period that Washington began his career in photography. To earn money to pay his bills at college, Washington became skilled as a daguerreotypist. He didn't look upon photography as an art form nor did he think of himself as an historian with a camera. Making photographs was merely a way to earn money, a "means to an end," as he described it.

Dr. Nathan Lord, the president of Dartmouth, criticized Washington for a poor choice of an occupation, as did his parents and some of his friends. But Washington did a thriving business as a daguerreotypist, and numbered members of the Dartmouth faculty and many people of the town of Hanover as his customers.

Augustus Washington never managed to graduate with his Dartmouth class. In 1844, after he had earned enough money to settle his debts, Washington quit school, gave up his daguerreotype business, and moved to Hartford, Connecticut. There he became a teacher at the North African School, one of the city's two schools for black children.

The North African School was housed in Hartford's Talcott Street Congregational Church. The Reverend James W. C. Pen-

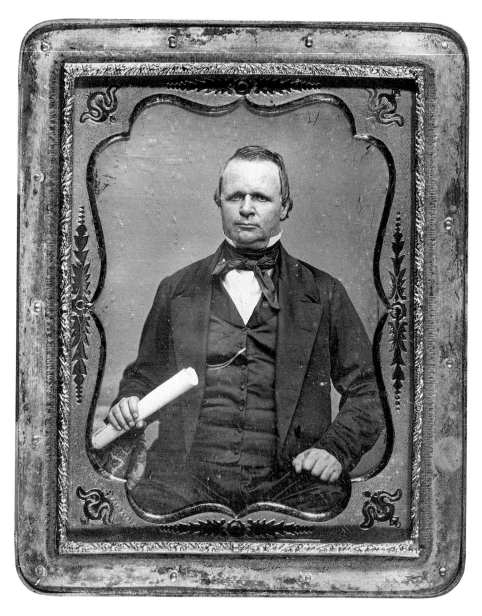

Above: Dating to about 1850, Augustus Washington's daguerreotype portrait of Eliphalet A. Bulkeley, one of Hartford's most distinguished citizens, is notable for its sharp focus and great clarity.

Right: Bulkeley's wife, Lydia, poses in a fancy black dress with a lace collar. Her portrait and that of her husband are in decorated leather cases with heavy silver frames.

nington, the church's pastor and one of the most noted black leaders in Connecticut, had made the church a center for antislavery activities.

The Reverend Thomas Robbins, another Hartford minister and a member of the city's School Society, visited the North African School in 1844 and 1845 to appraise conditions there. In his reports, now to be found in the archives of the Connecticut Historical Society, Robbins described Washington as " . . . a competent, good teacher. Well educated." He added, "The teacher deserves encouragement." Robbins also noted that the school didn't have enough books for all its students but that Washington was supplying some from his own library.

Washington opened a daguerreotype studio in Hartford in 1847. It could well have been Hartford's first photographic parlor, for in

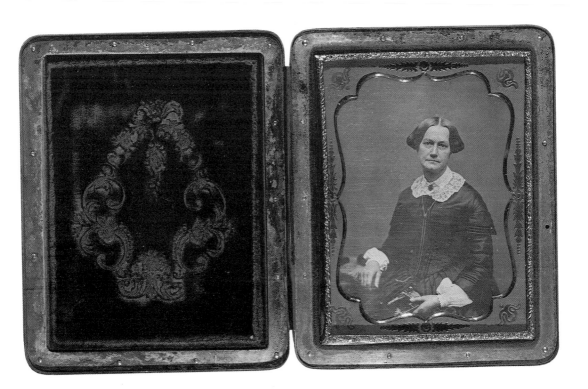

subsequent years Washington advertised the studio as "the oldest Daguerrian [sic] Establishment in this city."

Washington left the studio in 1848, turning it over to Samuel Cooley, who later was to become well known as a Civil War photographer. By 1850, however, Washington had returned to Hartford to take over operation of the studio again. In newspaper

Washington's decorated daguerreotype cases often were stamped with the name and address of his gallery.

advertisements, he listed the studio's address as 136 Main Street, which also served as his home. Washington later opened a second studio in Hartford, also on Main Street.

According to census records for the city of Hartford for 1850, Augustus Washington got married that year. His bride was nineteen-year-old Cordelia Aiken, a New Yorker. The couple were to have three children, two boys and a girl.

Washington now turned his attentions toward developing a successful business. In an advertisement in *The Weekly Citizen* in November, 1851, Washington declared that he was "determined to take as good or better likenesses than anyone in this state, at prices cheaper than any in this city . . ."

For a daguerreotype portrait, Washington charged from fifty cents to ten dollars, depending on the quality of the mirrored plate and the type of frame and case the sitter selected. Washington also sold lockets and bracelets for displaying portraits.

It wasn't absolutely necessary for one to visit Washington's studio to have a portrait made. Washington was willing to travel. As an advertisement of his noted, " . . . likenesses taken of invalids and deceased persons at their residence either in the city or country." Another advertisement noted that Washington employed "some of the best artists" in the country.

An article in a Philadelphia newspaper in 1852 hailed Washington as "an artist of fine taste and perception . . ." It observed that his studio was " . . . perhaps the only one in the country that keeps a female attendant and dressing room for ladies . . ." The article said, "He recommends . . . black dresses to be worn for sitting and those who go unsuitably dressed are supplied with drapery and properly enrobed."

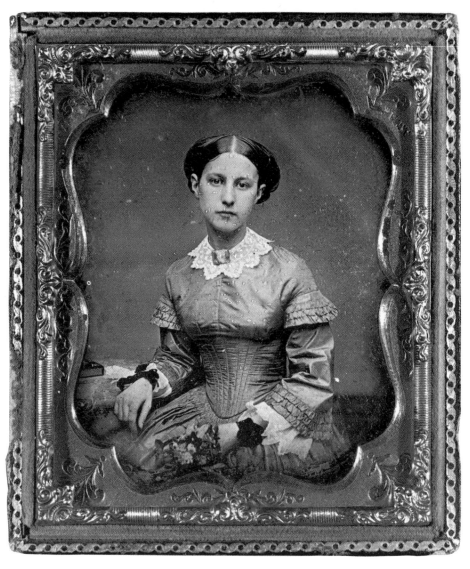

Washington's portrait of Sarah Taintor Waterman is typically solemn and dignified.

Like other daguerreotypists of the day, Washington specialized in portraits, in faces and figures, not landscapes nor scenic views. In

the manner in which he posed his subjects, the quality of the lighting, and the clarity he achieved in getting the image on the silver-plated sheet, Washington showed a high degree of professionalism.

He often photographed the city's most distinguished citizens. Two of the several Washington daguerreotypes that are owned by the Connecticut Historical Society depict Eliphalet Bulkeley and his wife, Lydia. The Bulkeleys were one of Hartford's elite families. Eliphalet Bulkeley was a lawyer, a Hartford judge, one of the city's leading political figures who, in his later years, prospered in banking and insurance. Morgan, one of the Bulkeley's three children, became a Connecticut governor and senator and served as the first president of baseball's National League. Washington's stately portraits of the Bulkeleys are encased in heavy silver frames.

During the time he operated his photographic studios, Washington kept active in the antislavery movement. He was friendly with some of the nation's abolitionist leaders, including William Lloyd Garrison, the founder of the *Liberator*, the famous antislavery newspaper. Garrison proclaimed that blacks were as much entitled to "life, liberty and the pursuit of happiness" as whites.

When Garrison visited Hartford in June, 1853, to attend a Bible convention, he posed for a portrait photograph at Washington's studio. Washington later mailed the picture to Garrison at his home in Boston as a gift for his wife.

Despite the success he enjoyed as a photographer, Washington got little satisfaction out of his profession—or his life. Slavery and the conditions of black Americans were always uppermost in his mind. He noted that state constitutions had recently been rewritten to give more rights to whites and fewer to blacks. Connecticut's constitution of 1818, for example, prohibited blacks from voting.

Only white males could vote. As an owner of a Hartford business establishment, Washington would have had to pay taxes but would not have been permitted to cast a ballot in city, state, or national elections. To Washington, this was "taxation without representation."

Blacks, Washington noted, "are shut out from all the affairs of profit and honor, and from the most honorable and lucrative pursuits of industry, and confined as a class to the most menial and servile positions in society."

Washington was dissatisfied with the efforts of the abolitionists, who called for an immediate end to slavery. Washington, on the other hand, was more a colonizationist, preferring a separate state for black Americans. Washington believed " . . . it would be better for our manhood and intellect to be freemen by ourselves than political slaves with our oppressors."

As early as 1844, while still a college student, Washington had begun negotiations for the purchase of a tract of land in Mexico where African Americans could be settled. But Washington had to abandon his plan when Mexico went to war with the United States in 1846. Canada, the West Indies, British Guinea, and parts of South America were other sites considered by Washington for African-American settlements. He eventually fixed upon Liberia on the west coast of Africa.

Liberia owed its existence to the American Colonization Society, an organization founded in 1816 and supported by antislavery groups and some slave owners who shared a desire to provide a homeland for free blacks outside of the United States. The organization bought a tract of land on the West Coast of Africa and named it Monrovia after James Monroe, who became President of

the United States in 1817. The first settlers, a group of 114 freed slaves, arrived in Monrovia in 1822, to be almost entirely wiped out by disease.

More settlers arrived in the years that followed. In 1838, Monrovia joined with other settlements that had been established to form the commonwealth of Liberia. The new nation's capital took Monrovia as its name.

The work of the American Colonization Society was hampered by a lack of money and disputes with antislavery organizations. Washington noted that the abolitionists and colonizationists could have been more effective if they could have stopped quarrelling, if, as he put it, " . . . they had wasted less ammunition firing at one another."

Washington's interest in immigrating to Africa was spurred by George Seymour, a black friend of his from Hartford. Seymour had gone to Liberia, inspected conditions there, liked what he saw, and had come back to Hartford to get his family and his belongings before returning to Liberia to live. In a letter to Seymour, Washington pleaded that in two or three years he would shake hands with him on the banks of Liberia's St. John River.

Washington kept his promise. In March, 1853, he announced in the *Hartford Daily Courant* that he was giving up his studio at 136 Main Street "for the purpose of foreign travel, and to mingle in other scenes of activity and usefulness." The "foreign travel" was an ocean voyage to Liberia.

Late in 1853, Washington was one of fifty-three passengers aboard the chartered sailing ship *Isla de Cuba* that left New York bound for Monrovia. Three other settlers were from Connecticut. Most—thirty-two—were from Pennsylvania. Washington's wife

and their children went with him. Before his departure, Washington made arrangements for his Hartford studios to be taken over by another photographer, G. V. Davis.

At first, Washington seemed discontented with his African home. Letters of his that appeared in the *New York Tribune* were critical of life there. But when a friend of Washington's from Liberia visited Hartford in March, 1855, he said Washington's message was: "Tell my friends that I am perfectly satisfied with the country notwithstanding my letters in the *New York Tribune*."

Washington had taken several hundred dollars' worth of daguerreotype equipment and supplies with him to Liberia. During his first year there, he helped to support himself and his family by working as a portrait photographer.

A number of daguerreotypes, believed to have been made by Washington in Liberia, are now in the hands of the Library of Congress. One depicts a Liberian diplomat. Others show Liberian friends. Like his earlier portraits, these reflect enormous dignity and personal pride.

Washington worked as a photographer for less than a year, or until his photographic supplies were exhausted. But by that time, he had developed other sources of income. He built two houses that he rented out, one for $75 a year, the other for $100 a year. He taught Greek and Latin to the senior class at a Monrovian high school, a job that took an hour a day and paid him $260 a year. But most of Washington's time and effort went into farming.

A letter from Washington appeared in the *Hartford Daily Courant* in September, 1858. In it, he summed up his situation. His crops included several acres of rice, casavas, and sugarcane. He had some

Washington is believed to have made this daguerreotype portrait of a Liberian diplomat after his arrival in Liberia in 1853.

cattle, chickens, ducks, and turkeys. "After a residence of four-and-a-half years, commencing with very small capital, thrown entirely on our own exertions and resources, we must still say that we love Liberia . . . because we have not seen or heard of any place on the eastern or western continent that we could like better."

Edward Weston, one of the most important twentieth-century photographers, once set down what he felt to be the qualities of the well-made photograph: "It should be sharply focused," Weston said, "clearly defined from edge to edge—from nearest object to most distant. It should have a smooth or glossy surface to better reveal the amazing textures and details to be found only in a photograph. Its value should be clear-cut, subtle or brilliant, never veiled."

These qualities pretty much define Augustus Washington's daguerreotypes. Yet he was a photographer for only about ten years. One can only speculate what artistic and business success Washington might have enjoyed had he not felt forced to renounce his country of birth and abandon his profession.

These portraits of Urias R. McGill and his wife are also thought to have been made by Washington during his first months in Liberia.

THREE

James P. Ball

"His fame has spread . . . through nearly every state of the Union, and there is scarcely a distinguished stranger that comes to Cincinnati but, if time permits, seeks the pleasure of Mr. Ball's artistic acquaintance." That's how a magazine of the time—*Gleason's Pictorial Drawing Room Companion*, April, 1854—spoke of James Presley Ball, one of the most renowned black photographers of the nineteenth century. Ball owned and operated the biggest and most magnificent gallery west of the Appalachians.

It wasn't merely the size of his operation that was impressive. He also won acclaim for the quality of his work. *Gleason's Pictorial* praised Ball for having "the best materials and finest instruments" and for taking daguerreotypes with "an accuracy and softness of expression unsurpassed by any establishment in the Union."

Ball's work won enthusiastic praise from local newspapers, too. "Ball takes the best pictures in this city, has the best operatives in this country, and the finest gallery in the West," noted the *Cincinnati Daily Enquirer* in July, 1854. "He has acquired a worldwide reputation as an artist and is well worthy of the praise his works have received throughout the country . . ."

Little is known of J. P. Ball's early life. It is believed that he was born in Virginia in 1825 and grew up in Cincinnati. He was twenty years old and visiting White Sulphur Springs, Virginia, when he met John B. Bailey, a black daguerreotypist from Boston. The encounter was a turning point in Ball's life. From Bailey, Ball learned how to create a daguerreotype, that is, how to pose a subject and fix an image on a chemically prepared metal plate. He must have been enthusiastic about what he had learned, for when Ball returned to Cincinnati in the fall of 1845, he opened a one-man daguerreotype studio.

To be able to do so, Ball would have had to have been a "free Negro," not a slave. A free Negro could own property but he or she had few other rights. He or she was only partly free. Indeed, in some areas, there was hardly any difference between free Negroes and slaves.

There were several ways in which an African American in bondage could become a free Negro. Sometimes slaves were handed their freedom through wills, that is, a slave owner might specify that his slaves were to be set free upon his death. Occasionally a slave might be able to save enough money to purchase his or her freedom and, of course, many thousands of African Americans sought freedom by simply running away from their masters.

Ball's daguerreotype of Olivia Slocum Strong dates to 1853–1855.

Children born of free Negro mothers were also considered free. James P. Ball, presumably, fell into this category.

Free Negroes tended to settle in urban areas, the southern cities of Baltimore, Washington, Charleston, Mobile, and New Orleans, and the northern cities of Boston, New York, Cincinnati, and Philadelphia. In such cities, they were likely to find greater social freedom and more economic opportunities than in rural areas.

Ball's first attempt at running a daguerreotype studio was a fast failure. In his first three months of operation in Cincinnati, he had two customers, and only one of these paid cash. The other sought credit.

Ball closed the studio and began working as a traveling daguerreotypist, a trade that was common in the early days of photography. The traveling daguerreotypist drove his horse-and-wagon studio from one town to the next, often advertising his planned arrival in local newspapers. He would set up a temporary studio in a local boardinghouse or inn or even in an empty lot, and then offer the public the opportunity to examine samples of his daguerreotypes and have their own portraits made.

Ball's travels took him to Pittsburgh, where he arrived in the spring of 1846, and from there he moved on to Richmond, Virginia. When Ball got to Richmond, all he had, besides his photographic equipment and chemicals, was a single shilling, a coin worth about twenty cents. This he gave to the mover who hauled his trunks into his new quarters.

The determined Ball then took a job in the dining room of a Richmond hotel. When he had saved a hundred dollars, Ball rented a furnished room near the state capital and turned it into a daguerreotype studio. This time it was different. "The Virginians rushed in crowds to his room," according to one account. "All classes, white and black, bond and free, sought to have their lineaments stamped by the artist who painted with the sun's rays."

By 1849, Ball had closed down his operation in Richmond, and was back in his hometown of Cincinnati, where he opened another studio, which proved instantly popular. "His gallery is thronged by citizens and strangers," said a newspaper of the time. His success encouraged Ball to expand. On New Year's Day, 1851, Ball opened a larger and much more lavish studio in a fashionable part of the city.

During the early 1850s, Cincinnati, the sixth largest city in North

America, was booming. The countless steamboats and canal boats that plied the Ohio River and other of Ohio's many waterways had helped to make Cincinnati the economic capital of the nation's interior and the fastest-growing city on the continent.

Cincinnati was also a center of growth and development in photography. Ezekiel Hawkins and Thomas Faris, both highly skilled daguerreotype artists, had settled in Cincinnati as early as 1843.

Ball called his splendid new establishment "Ball's Great Daguer-

"Ball's Great Daguerrian Gallery of the West," as he called it, had a nine-man staff and was said to be equipped with the "best materials and finest instruments."

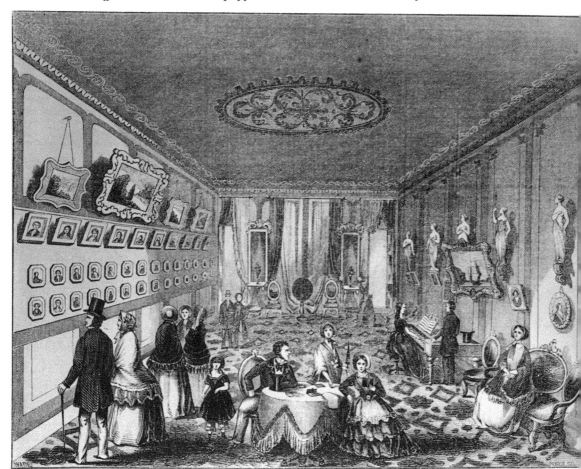

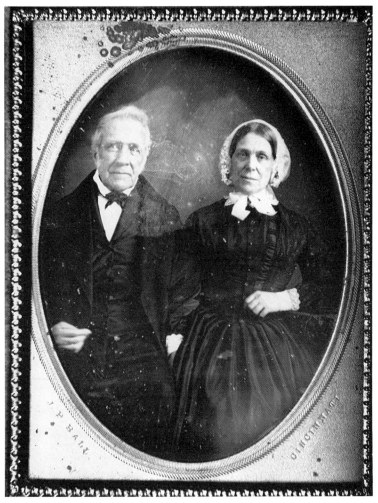

The brass mat that frames this daguerreotype of a fashionably dressed couple is stamped "J.P. Ball" in the lower left corner and "Cincinnati" in the lower right corner.

rian Gallery of the West." In its grandeur, it rivaled, if not surpassed, the glittering galleries established by Mathew Brady and Jeremiah Gurney in New York and those in Boston, Philadelphia, and other Eastern centers of photography.

In describing the gallery, *Gleason's Pictorial Drawing Room Companion* said, "The establishment is located in Cincinnati on Fourth Street . . . in Weed's large building. It occupies four rooms and one ante-chamber on the third, fourth, and fifth stories." Two of these, said the magazine, were "fitted up in the best manner" as operating rooms.

"The third room is the work-shop where the plates are prepared and likenesses perfected." These were said to be "possessed of the best materials and finest instruments." In the fourth room, or "great gallery," the walls were "tastefully enamelled by flesh-colored paper, bordered with gold leaf and flowers."

According to *Gleason's Pictorial*, Ball had nine men "superintending and executing the work of the establishment." Each man was said to be "perfect in his peculiar branch."

The most striking feature of Ball's gallery was a series of pictures that depicted scenes of black life along the Ohio, Susquehanna, and Mississippi rivers, and Niagara Falls. Black artist Robert S. Duncanson, who may have worked for Ball at one time, was represented by six of his splendid landscape paintings.

In 1855, a lecture that was to be delivered along with a presentation of the panorama's images was published in Cincinnati by Achilles Pugh, who was active in the movement to have slavery abolished. Its lengthy title was as follows: *Ball's Splendid Mammoth Pictorial Tour of the United States, Comprising Views of the African Slave Trade of Northern and Southern Cities, of Cotton and Sugar Plantations, of the Mississippi, Ohio, and Susquehanna Rivers, Niagara Falls, etc.*

Not much is known of Ball's personal life during this period. We do know that Ball married Virginia Burns in 1848 or 1850. Two children were born of the marriage, a son, James P. Ball, Jr., on

October 9, 1851, and a daughter, Estella, whose birth date is not known.

As Ball's business prospered and grew, he began making it a family affair. His wife and two children eventually became photographers. Ball's brother-in-law, Alexander Thomas, the husband of his sister Elizabeth, joined the gallery staff in 1852. Two years later, Alexander Thomas became Ball's partner, and the two men opened another gallery. Known as Ball & Thomas, the studio did a thriving business.

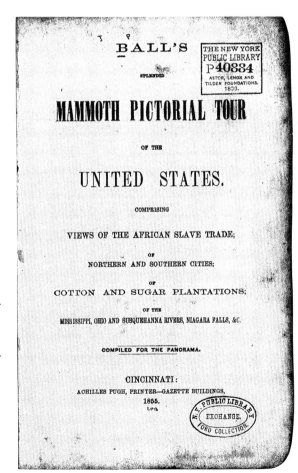

Ball's gallery featured a panorama of photographs depicting scenes of black life. This is the cover page of a lecture to be delivered with a presentation of the panorama's images.

Like all major studios of the day, operations at Ball & Thomas were highly specialized. The actual task of making the picture was performed by a camera operator. Assistants prepared the metal or glass plates and did the laboratory work necessary to developing and fixing the image. Still others were retouchers or colorists, hand-tinting the black-and-white image with a very fine brush or cotton swab. At Ball & Thomas, Ball's brother, Thomas, worked as a camera operator. A nephew was employed as a retouch artist.

"He takes decidedly the best pictures to be got in Cincinnati," the *Daily Enquirer* said of Ball, who worked diligently to remain at the top and advertised regularly in local newspapers. And Ball sent members of his staff to Eastern cities, where photography flourished, to learn of any technical advances that might have taken place. A Cincinnati newspaper noted in July, 1859, that two "gentlemen" from Ball's gallery "have gone East on a tour of observation determined to bring back with them every improvement in the Daguerreian art."

During the mid-1850s, the daguerreotype began to slip in popularity as other forms of photographs began replacing it in the public's fancy. The ambrotype was one. Introduced in 1854, the ambrotype was similar to the daguerreotype in that it was usually small in size and devoted to portrait photography. The biggest difference was that the ambrotype's image was produced on glass, not on metal.

An ambrotype was made by first coating the glass plate with a weak solution of collodion. The plate was exposed in the camera, developed, fixed, and dried—a process that produced a negative on glass. Given a backing of black velvet, black cardboard, or black

varnish, the negative image took on the appearance of a positive print.

Ambrotypes cost less to produce than daguerreotypes and they also were easier to color. They were used chiefly for portraits, but they were not popular for very long. A glass-plate negative could be used to make multiple prints on paper. Before the end of the 1850s, ambrotypes were being replaced by paper prints, the basis of modern photography.

During the early 1860s, the ability to print countless copies of a photographic image on paper helped to trigger the popularity of small card photographs, known as *cartes de visite* ("visiting cards"). Each *carte* took the form of a 2¼ × 3½-inch photograph that was mounted on a slightly larger strip of stiff cardboard. Overall, the *carte de visite* was about the same length as a modern-day baseball card, but somewhat slimmer.

Card photographs usually featured carefully posed studio portraits. While family members were frequent subjects, *cartes* also bore the likenesses of noted people of the time. Images of President Abraham Lincoln were popular among *carte* collectors, as were those depicting members of the President's cabinet, Civil War generals, statesmen, actors and actresses, clergymen, and authors. Scenic views or reproductions of works of art could also be made. The reverse side usually carried the photographer's name and address.

Cabinet cards, introduced late in the 1860s, eventually replaced *cartes de visite* in the public's favor. The cabinet card looked like a king-sized version of the *carte de visite*. It measured 4 by 5½ inches and was mounted on a slightly larger piece of thick cardstock.

Cabinet cards mushroomed in popularity during the 1870s. Since

During the 1860s, Ball & Thomas
produced small card-photographs
known as cartes de visite. This one
is typical. The woman is unidentified.
The reverse has the photographer's
name and address.

BALL & THOMAS,

Photographic Art

GALLERY,

120 W. Fourth Street, near Race.

CINCINNATI, O.

photographers now had a larger area on which to present their work, they became more creative, giving greater attention to lighting and backgrounds and the way in which the subject was posed.

Ball adapted quickly to these changes as they occurred. His studio, which had once offered daguerreotypes exclusively, mastered the production of ambrotypes, then *cartes de visite* and cabinet cards. To Ball, change represented an opportunity for growth and expansion.

Ball's soaring reputation helped to attract several well-known individuals of the day to visit his studio to sit for portraits. These included Frederick Douglass, the famed black lecturer and writer, who founded and edited *The North Star*, later *Frederick Douglass' Paper*, a spirited antislavery newspaper. Another visitor was Henry Highland Garnet, an Afro-American clergyman and, like Douglass, a leader in the abolition movement. During the Civil War, many Union soldiers were photographed at the Ball studios.

Ball's life took on a restless quality in the 1870s. He left Cincinnati to settle in Minneapolis, where he and his son opened a studio. An advertisement that Ball placed in the *St. Paul Western Appeal* on March 19, 1887, said, "He [Ball] is one of the oldest and best photographers in the Northwest and is the only colored man in the business."

In July, 1887, a local newspaper reported that Ball had married Annie E. Ewing, a schoolteacher from Mobile, Alabama, who had recently moved to Minneapolis. (It is not known whether Ball's first wife had died or whether the couple had divorced.) Ball's two children from his first marriage and friends and relatives of the couple attended the wedding.

The same year, 1887, Ball was named to be official photographer

of the celebration held in Minneapolis-St. Paul honoring the twenty-fifth anniversary of the Emancipation Proclamation. John Mercer Langston, who had served as a law professor and dean at Howard University for almost a decade and later won election as a Congressman from Virginia, was one of the principal speakers. Afterward, Ball advertised in the *St. Paul Western Appeal* that he had available photographs of Langston, plus "a lot of groups," which could be purchased at five cents apiece. The advertisement also noted, "He takes fine cabinets [cabinet cards] for $1.00 per dozen."

Quite suddenly, Ball, accompanied by his son, was on the move again. Helena, Montana, was his destination this time. The two opened a photographic studio there in 1888 that was to remain in operation until 1900.

During his years in Helena, Ball became involved in politics. He was elected as one of the "colored" delegates to the state Republican convention of 1894. He also was the first African American to be nominated for the office of county coroner, but he declined the nomination because he was too busy running his studio. He said, "My business interests are such that they would be greatly jeopardized." But Ball did find time to become president of the Afro-American Club, a statewide social and political organization. He was also a steward of Helena's African Methodist-Episcopal Church.

Ball's son was active in the field of civil rights. He edited the *Colored Citizen*, a weekly newspaper that was "devoted to the social, moral, and industrial interests" of Montana's African-American cit-

This cabinet card shows "Joe," who cooked for the Mings, one of Helena's wealthiest families.

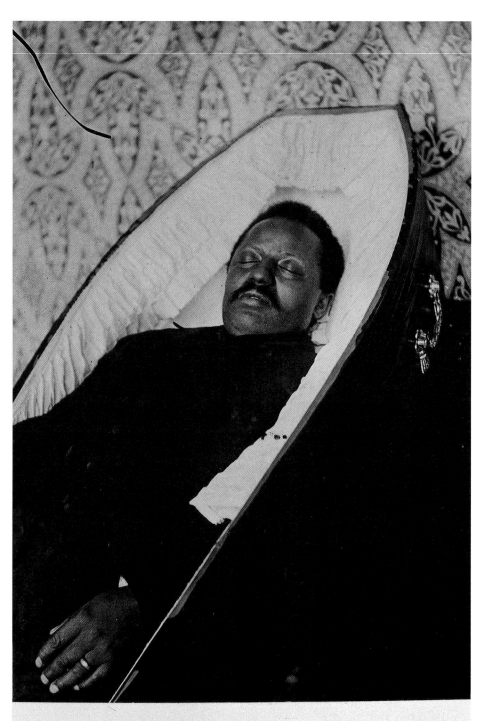

J. P. Ball & Son, Helena, Montana.

OPPOSITE POSTOFFICE.

SIGN OF THE RED BALL

izens. At the time, the cities of Helena and Anaconda were in competition for designation as the state capital of Montana. The *Colored Citizen* supported Helena. It proved to be a winning pick, for Helena was the choice of Montana's voters in a statewide election held on November 6, 1894.

Ball's son made his father the subject of an article that appeared in the *Colored Citizen* on September 3, 1884. It said, "Helena enjoys the notoriety of having the only colored photographer in the Northwest . . . He is one of the oldest members now in the profession . . . and has had the satisfaction of taking numerous medals for superior work over many of the most skillful and artistic competitors in the largest eastern cities."

The photographs produced by J. P. Ball during his years in Helena are perhaps the best of his career. Some were typical portraits or devoted to family groups, while others depicted notable buildings in Helena or special events, such as the laying of the cornerstone for the state capitol. Ball also photographed local hangings. These he covered in the manner of a modern-day photojournalist, with a series of photographs, picturing the victim being brought to the gallows, his final moments, the hanging itself, and, finally, in his coffin.

The Ball family was on the move again in 1892, when father and son opened the Globe Photo Studio in Seattle, Washington. An announcement that appeared in the *Seattle Post-Intelligencer* on March 27, 1892, described the studio as being "handsomely fitted

William Biggerstaff in his coffin. A one-time slave, Biggerstaff was convicted of murder—he pleaded self-defense—and was hanged. Ball also photographed Biggerstaff's execution.

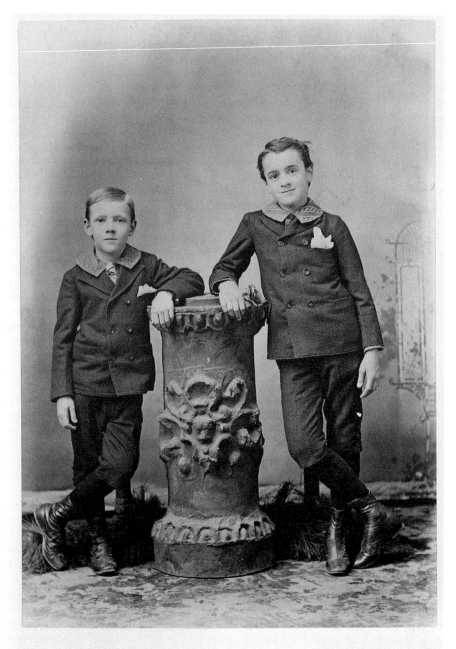

These boys, presumably brothers, wore decorated collars and ties, double-breasted jackets, calf-length trousers, and high-topped shoes to pose for Ball's camera.

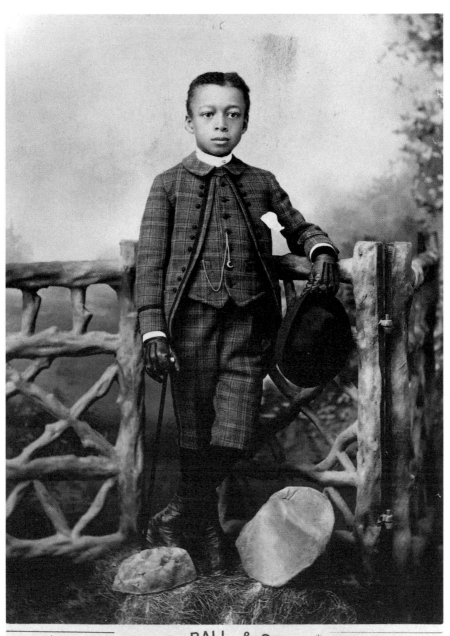

For his portrait picture at Ball's Helena, Montana, studio, this young boy wore gloves and a plaid suit, and carried a pocket watch and chain.

up" and advised that "all callers will be made welcome." Several members of the Ball family worked at the studio at one time or another over the next decade.

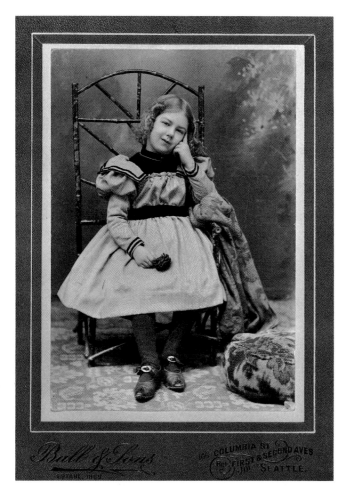

Ball's studio in Seattle produced this cabinet card. It pictures Lottie Berg, daughter of a pioneer furrier.

Ball, who turned seventy-five in 1900, not only helped out at the studio but he was involved in the organization of Shriners' lodges throughout the state. The Shriners, a fraternal society, are devoted to charitable works and health programs. Ball also found time to sell advertising for the *Seattle Republican*, the local newspaper.

During these years, Ball was plagued by painful arthritis. He is said to have sought treatment in the soothing waters of Hot Springs, Arkansas, and from the warm sun of Hawaii. He is believed to have died in Hawaii in 1904.

James P. Ball and his remarkable career, which covered more than half a century and involved major cities in several different states, have not gone unnoticed. Ball was the subject of a book published in 1993 titled *J. P. Ball, Daguerrean and Studio Photographer*. And in 1992, as noted earlier, a Ball daguerreotype attracted a record amount in the auction market, a tribute to Ball's artistry.

Through the years, there have been other photographers who managed to achieve Ball's level of skill. But in terms of energy and business enterprise, J. P. Ball was without equal.

FOUR

The Goodridge Brothers

East Saginaw, Michigan, on the banks of the Saginaw River, doesn't seem to be a likely location for a photography business that, in 1886, was described by the *Cleveland Gazette* as the "largest concern of its kind in the United States." But East Saginaw is where the three Goodridge brothers, descendants of what had once been a slave family, set up shop. They specialized in both portraits and scenic views. Their studio, if not "the largest concern of its kind," at least came close to that description.

The Goodridge brothers—Wallace L., William O., and Glenalvin J.—were among the nation's first photographers. The first Goodridge studio, operated by Glenalvin, opened for business in York, Pennsylvania, in the 1850s. They operated their studio in Michigan's Saginaw Valley for more than fifty years, from 1866 through 1922.

As this may suggest, one reason the Goodridges are important is because they endured. They operated during good financial times, and bad. True professionals, they adapted quickly and easily to the many technical changes in photography that took place during their lifetimes.

In 1886, the Goodridges were hailed for having an array of photographic equipment that included an "instantaneous camera" that enabled them to take photographs of "cars, vehicles, or anything in motion." They worked in every medium, producing daguerreotypes and ambrotypes, *cartes de visite* and cabinet cards, tintypes and stereo views. They turned out tiny gem photos, no larger than a postage stamp, and giant panoramas that depicted multitudes at social gatherings. They published a magazine called *Picturesque Michigan* and provided news photographs to *Harper's Weekly* and *The New York Graphic*. They sold their photographs to customers in South America, the West Indies, England, and virtually every state and territory of the United States.

Dr. John V. Jezierski, a professor of history at Saginaw Valley State College in Saginaw, who has had a deep interest in the Goodridges for more than twenty years, has called their work "imaginative, sensitive, and creative." Some of their photographs, he says, demonstrate "their appreciation of the interplay between light and shadow, their acute sense of detail, [and] their awareness of the impact of perspective . . ." William, the youngest of the Goodridges, was "the real artist of the family," according to Professor Jezierski.

Glenalvin Goodridge, the oldest of the Goodridges, was one of the first black photographers to earn official recognition for his work. In 1856, he won a cash prize for the "best Ambrotypes' at

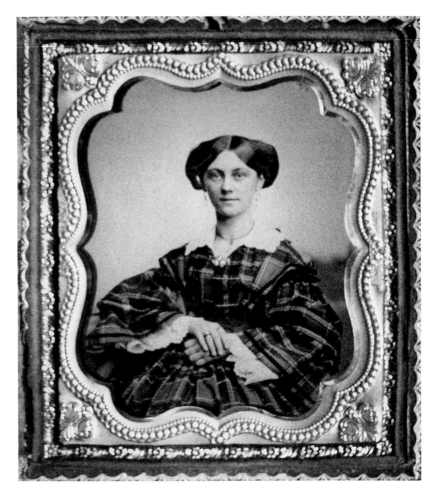

An early ambrotype portrait from the Goodridge Studio in York, Pennsylvania.

the York County Fair in Pennsylvania. (Similar to a daguerreotype in size and appearance, the ambrotype is a negative on glass, which, when backed by a dark surface, appears as a positive image.)

Earlier generations of Goodridges were slaves. The boys' grandmother was a slave who was owned by Charles Carroll (known as Charles Carroll of Carrollton), a leader of the American Revolution

from Maryland and signer of the Declaration of Independence. Carroll sold her to a Baltimore physician. In 1805, she had a son, William C. When he was eleven years old, the physician sent William to York, Pennsylvania, to work as an apprentice leather-maker in the tannery of William Dunn, a minister and craftsman. William worked for Reverend Dunn for ten years, whereupon the minister granted the young black man his freedom and gave him a suit of clothes and a Bible.

William went back to Maryland, worked as a barber, saved some money, and got married. Later, he returned to York with his bride, settled down, and started raising a family. Besides the three Goodridge boys who were to pursue careers in photography, at least two other sons and a daughter were born to the couple.

William C. Goodridge became a highly successful York businessman. The family office building was, at five stories, the tallest structure in York. Because of their father's success and the fact that he was a free man, the Goodridge children were able to pursue their special interests, one of which was photography. Glenalvin, the oldest of the Goodridge children, is known to have worked as a daguerreotypist in Baltimore, Maryland, and then he opened his studio in York, where he was given space in the Goodridge Building.

In addition to their pursuit of business success, the Goodridges were active in the Underground Railroad, a system of helping runaway slaves to escape to Canada and other places of safety. Like other free blacks and sympathetic whites, the Goodridges used specially designed hiding places to conceal the runaways. They were built into their rambling office building and were to be found in their home on Philadelphia Street in York as well.

The passage of the Fugitive Slave Act of 1850, which imposed heavy penalties for concealing or otherwise aiding runaways, triggered an era of slave-hunting and kidnapping in the North. It also served to expand the operations of the Underground Railroad— and undoubtedly also caused great tension for the Goodridge family.

The Underground Railroad flourished until 1861, when the Civil War erupted. The war produced even greater fears for the Goodridges. In the summer of 1863, Robert E. Lee's Confederate army advanced north out of Maryland toward Gettysburg, Pennsylvania, some thirty miles to the south and west of York. When news of Lee's bold thrust reached the Goodridges, the family, fearful that

Produced in Glenalvin Goodridge's "Extra Sky Light Gallery," this daguerreotype portrait dates to the late 1840s or early 1850s.

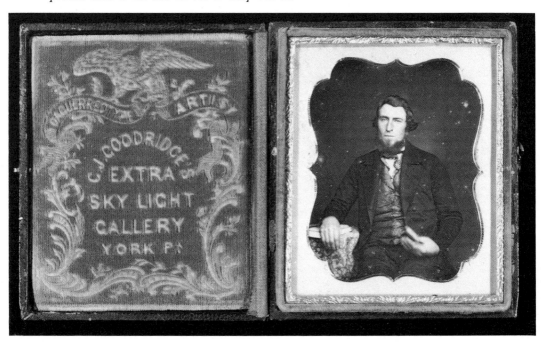

their activities with the Underground Railroad would make them targets of vengeful Southern soldiers, took flight.

Sometime between 1863 and 1868, the three Goodridge brothers settled in East Saginaw on the Saginaw River in eastern Michigan. (At the time, there were two Saginaws—East Saginaw and, on the opposite side of the river, Saginaw City.) No one can say for sure why the Goodridges chose the Saginaw Valley as their new home. It may have been because a married sister, Mary, had moved there from York. City directories of the time indicate there were only about seventy black men and women living there out of a total population of almost twenty thousand.

Whatever the reason, it was a fortunate choice. The Saginaws were booming, thanks to the lumber industry that was growing by leaps and bounds. Before long, the Saginaw Valley would be known as "the pine lumber capital of the world." Some fifty-seven lumber mills were in operation in the area, employing about 8,000 men. The Saginaws were also headquarters for a flourishing salt industry. More than a hundred wells were producing salt.

East Saginaw itself was a city of broad, paved streets, lovely parks, elegant homes, and fine hotels. It offered a new city hall and new library. "There are few if any cities in the United States as pleasant to live in as East Saginaw," said an article in the *Cleveland Gazette* in 1887, "and none that have any better schools or a larger number of . . . churches."

The Goodridge brothers owned and operated a photographic studio that was fitted out with what their advertising described as the "Largest and Best Sky-light in the State." Glenalvin died in 1866, leaving Wallace and William to carry on the partnership. The

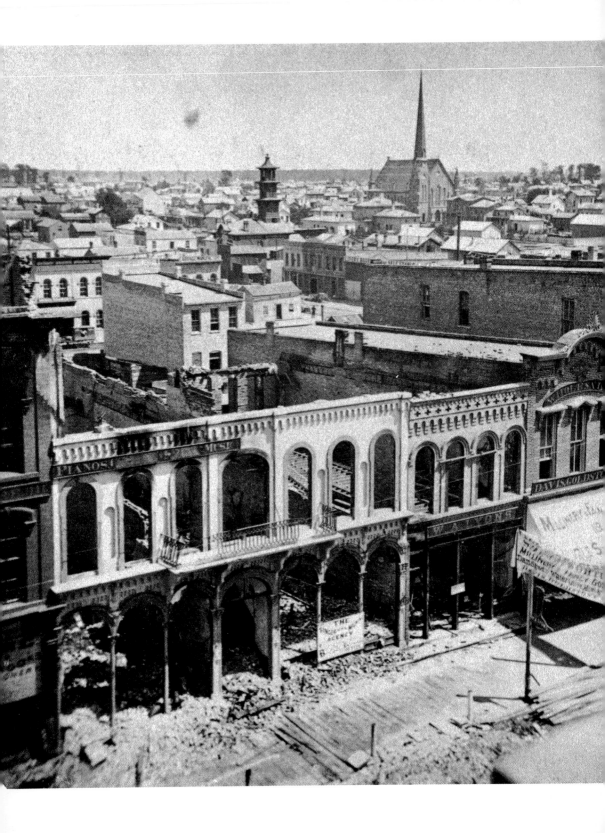

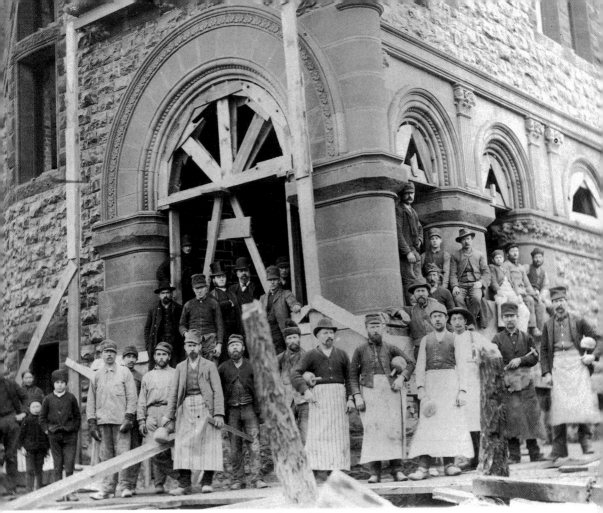

Above: Construction of Saginaw's Hoyt Street Library.

Left: The Goodridges often covered fires, floods, and other natural disasters. Fire ruins in East Saginaw are pictured here.

twenty-five-year-old Wallace became the senior partner after Glenalvin's death.

From their new quarters, the Goodridges produced portraits in all the popular forms of the time. They printed portraits and other images, not only on paper and cardboard, but on porcelain, linen,

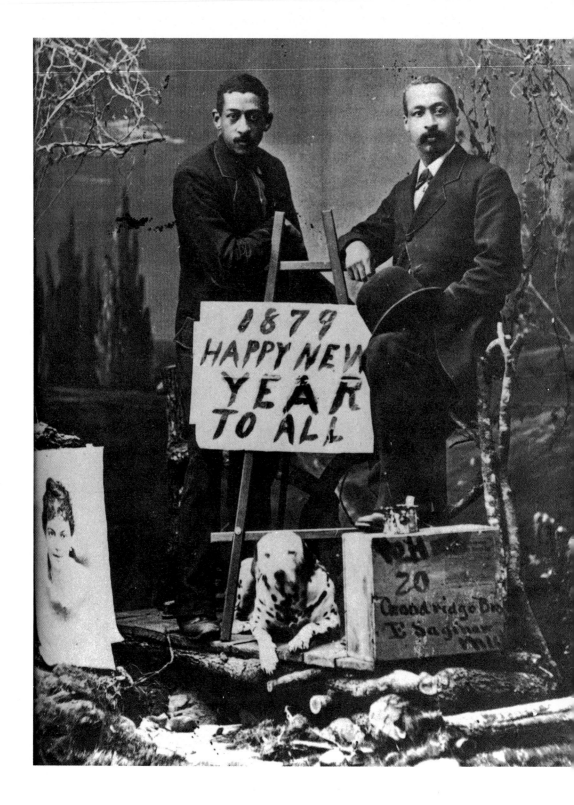

silk, and even on watch dials and the bottoms of teacups, if that's what a customer wanted. They made group portraits of Saginaw schoolchildren and offered such speciality items as wallet-size folding photographs that were used to record significant community events, such as the opening of the Genesee Street Bridge.

The Goodridge studio also produced a tremendous quantity of stereographic views, or stereo cards, as they are sometimes called. The stereograph is a pair of photographs of the same scene, each taken from a slightly different point of view. The two images are mounted side-by-side on a stiff rectangular card. When the two images are viewed through an optical instrument called a stereoscope, the viewer sees a single image that appears to be in three dimensions.

Beginning in the 1850s and continuing well into the 1900s, the viewing of stereographs in American homes compared to television watching today. Scenic views were especially popular.

The Goodridge brothers produced at least two different series of stereo cards. The first, called "Saginaw Valley Views," depicted East Saginaw and Saginaw City. A second, produced at about the same time, was called "Michigan State Views." The brothers promoted the cards with advertisements in local newspapers and city directories.

Besides the commercial work turned out by their studio, and the fact that they served virtually every family in the Saginaw Valley, the Goodridges also were the area's historians. In the years between

William O. and Wallace L. Goodridge in their New Year greeting of 1879 in East Saginaw.

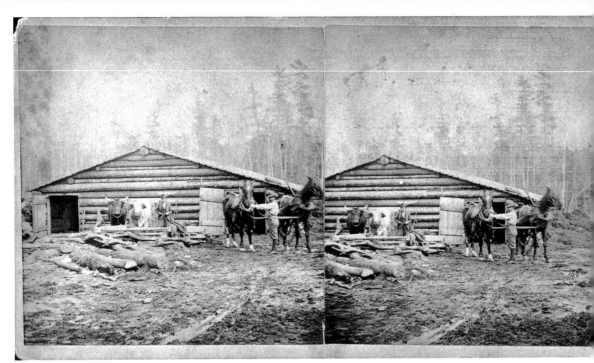

Stereo cards produced by the Goodridges included views of a lumber camp in Midland County, Michigan (above) and flood waters in East Saginaw in the 1870s (below).

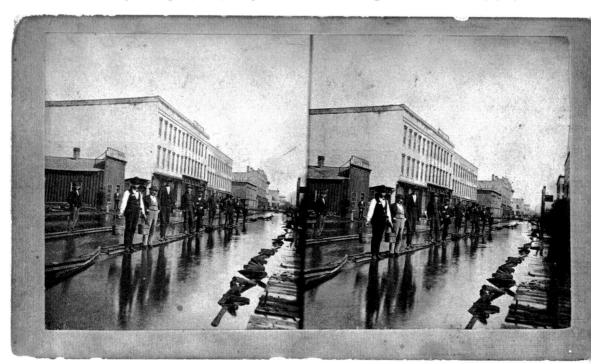

1866 and 1892, the two men visited countless lumber camps and mills in the Saginaw Valley, an area that covered more than a thousand square miles. They documented day-to-day life in the camps, the felling of the trees, the process of floating the logs to the sawmills, and the mills themselves, where the timber was cut into planks and boards of assorted shapes and sizes.

Wallace and William kept active in community affairs in the Saginaws and held a number of professional positions. They were officers of the Colored Debating Society, the Eastern Star Masonic Lodge, and Professional Photographers Association.

Curiously, few of the Goodridges' photographs depict African Americans. Professor Jezierski has noted that of the thousand or so photographs taken by the Goodridges that he has seen, less than twenty are of blacks.

The brothers did produce and sell small card photographs of Abraham Lincoln. The image was a copy of an existing photograph. "Otherwise," says Professor Jezierski, "there is seldom any politics in their work."

In January, 1869, Wallace Goodridge served as chairman of a committee that was formed to organize a celebration in commemoration of the Emancipation Proclamation. The festivities ended in tragedy. Upon returning home following the event, the Goodridges found their home and its contents had been destroyed by a fire of suspicious origin. Among their losses was the family library of more than a thousand books.

In 1872, the two brothers built a larger studio a few blocks south of their original location. The new building also served as their residence.

During their years of operation, the Goodridges saw enormous

changes take place in photography. The introduction of the dry plate was one. Invented in 1871, the dry plate was a small plate of glass that had been brushed with a thin gelatin coating that contained light-sensitive salts. Dry plates did away with the messiness of wet collodion plates and enabled a photographer to buy plates in the size for which his or her camera was designed, just as one buys roll film today.

Dry plates and the later development of ready-to-use photographic paper made photography and photo processing much simpler. The Goodridges welcomed such changes, using them to become more efficient and productive.

In 1889, the U.S. Department of Agriculture singled out the Goodridge brothers for recognition when the Chief of Forestry ordered fourteen of their scenic views depicting the lumber industry. The photographs were exhibited at the Paris Exposition held that year.

William and Wallace were partners until William's death in 1891 at the age of forty-five. Wallace continued the business for almost another thirty years, until he died in 1922 at eighty-one. The Goodridge studio was in operation for fifty-six years. So, besides their reputation for excellence and the notable size of their operation, the Goodridges set a record for longevity that few other businesses of the time could equal.

Cornelius M. Battey

Cornelius M. Battey was the first African American to earn a reputation not merely as a skilled photographer but also as a photographic artist. "His life . . . was one increasing struggle to liberate . . . the fluid graces of an artist's soul," said an article about him in *Opportunity* magazine. "For paintbrush and palette, he used a lens and shutters."

During the 1890s and early decades of the 1900s, Battey was one of the small number of portrait photographers who sought to demonstrate that the camera could be used creatively to produce works of art. Photographer and editor Alfred Stieglitz, an important force in American photography, was the leader of the movement which came to be called "pictorialism." Stieglitz wrote that with pictorialism, photography has now "come to her own, and in the strength of maturity taken her place among her sister arts."

Pictorialists smoothed out the detail of their images by softening the focus of their lenses. Some sought to achieve a pictorialist quality by retouching the print or negative with ink, pencil, charcoal, or other materials. Edward Steichen, another leader in the pictorialist movement, often altered his portrait photographs by brushing on silver salts or other chemicals in an effort to increase their aesthetic appeal.

Battey's portrait of poet Paul Laurence Dunbar was produced in the pictorialist tradition. Dunbar, the son of an escaped slave, died in 1906 at the age of thirty-four. By that time, however, he had become the first African American to gain a national reputation as a poet. His books of poetry include *Lyrics of a Lowly Life* (1896), *Poems of Cabin and Field* (1899), *Lyrics of Love and Laughter* (1903), and *Lyrics of Sunshine and Shadow* (1905). Battey once described Dunbar as "the Poet Laureate of the Negro race." Dunbar also wrote four novels.

Battey's portrait of Dunbar captures the poet's personality. Dunbar, in formal dress, a closed hand at his face, is pictured in soft focus against a muted background. But the portrait doesn't merely impart what Dunbar looked like. It has an emotional quality. It is serious; it is somber. It creates a mood.

Other photographers of the day ridiculed the first pictorialists, saying that they were out of step with the times and calling their photographs "fuzzytypes." But in the end the pictorialists prevailed, and the public came to enjoy their portraits for their ability to convey a feeling, for their style and elegance and even their beauty.

Cornelius Marion Battey, born in Augusta, Georgia, in 1873, lived most of his early life in the North. His first job was in an architect's

Battey's portrait photograph of poet Paul Laurence Dunbar has many of the same qualities as a fine painting.

Cornelius Battey and his wife, the former Bessie Smith Rahn.

W.E.B. DuBois, one of the founders of the National Association for the Advancement of Colored People, is strong and resolute in this Battey portrait.

office in Indianapolis. He went on to work in a Cleveland, Ohio, photo studio. He later moved to New York and there became superintendent of the Bradley Photo Studio on Fifth Avenue, a job he held for six years. Patrons at Bradley's included such men as Prince Henry of Prussia and Sir Thomas Lipton, the British merchant and yachtsman.

Battey left the Bradley Studio to head the retouching department of Underwood and Underwood, the nation's best-known photographic organization. Still later, he was a partner in the Battey and

Warren Studio in New York. During this period, Battey produced a composite photograph that combined the portraits of fifty-one bank presidents. Titled "Kings of Finance," the composite appeared in *Everybody's Magazine* in November, 1910.

While in New York, Battey came to know W.E.B. (William Edward Burghardt) DuBois, who had graduated from Fisk College and was the first African American to receive a Ph.D. degree from Harvard University. DuBois was to become famous as an historian and sociologist and a leading figure in the fight against racial discrimination. In 1909, after major riots against blacks earlier in the decade, DuBois helped to found the National Association for the Advancement of Colored People (NAACP) and became editor of

Battey's portrait photographs were sometimes used as cover illustrations for The Crisis, *the official publication of the NAACP.*

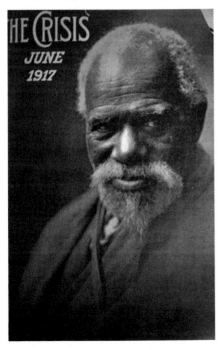

the NAACP magazine, *The Crisis*, which was described as "a record of every important happening and movement in the world which bears on the great problems of inter-racial relations and especially those which affect the Negro American." Portrait photographs of Battey's were sometimes used as cover illustrations for *The Crisis*.

In 1916, Battey put an end to his career in New York and returned to the Deep South, moving to Tuskegee, Alabama, where

In 1919, the Christmas edition of The Tuskegee Student *featured this example of Battey's artistry.*

he became head of the Photography Department at Tuskegee Normal and Industrial Institute. The school had been founded in 1881 by Booker T. Washington, who had been born a slave, to further the education of blacks.

For Tuskegee's students, Washington believed in a form of industrial education that would not incur the hostility of white Southerners and would, at the same time, enable blacks to be of service to their communities. He wanted Tuskegee's students to become farmers, mechanics, carpenters, brickmasons, and domestic servants. "There is as much dignity in tilling a field as writing a poem," he said. He encouraged the habits of thrift and perseverance, and the cultivation of good manners and high morals.

Of the forty or so buildings on the Tuskegee campus when Battey arrived, all but the first three had been built by students. The classes in brickmaking made all of the bricks the Institute used.

Printing, housepainting, tailoring, carpentry, blacksmithing, farming were other subjects taught. Women were schooled in nursing, plain and fancy cooking, candy-making, housekeeping, and laundry work. The school, which became Tuskegee University in 1985, was to grow from a single academic department with thirty students to a huge independent institution that emphasizes sciences, engineering, and other professions with a faculty of more than 350 and a student body of more than 3,300.

Booker T. Washington seemed to have little interest in political and civil rights for blacks. His emphasis was on industrial training as a means to self-respect and economic independence. For this, he was sharply criticized. Some historians have described his doctrine of vocational education as "education for a new slavery."

W.E.B. DuBois was one of Washington's opponents, accusing

him of ignoring "the higher aims of life." Most other blacks were not so critical. The vast majority hailed Washington as their leader. In 1901, President Theodore Roosevelt invited Washington to the White House and dined with him there, a move that underscored the fact that Washington was the preeminent black spokesman of the day.

Washington died at Tuskegee on November 14, 1915. He had served as Tuskegee's president for thirty-three years. His successor, Robert Russa Moton, who came to be called "The Builder," expanded Tuskegee's physical plant and boosted the school's financial reserves. Commandant of cadets at Hampton Institute at the time of his selection, Moton was also a sports enthusiast. His tenure at Tuskegee produced a golden era in athletic competition.

Battey arrived at Tuskegee in the year following Moton's appointment as president. But before taking on his assignment as the head of the new Division of Photographic Instruction, Battey got married. His bride was Bessie Smith Rahn. The wedding took place in New York City on November 2, 1916. The Batteys were to have four children, three daughters, Edith, Muriel, and Antoinette, and a son, Champlain.

While at Tuskegee, Battey photographed local events and institutions and also taught photography. And he continued his portrait work. Besides his portraits of Robert Russa Moton, at least one of which he produced in the pictorialist tradition, Battey photographed such notables of the day as President Calvin Coolidge and Chief Justice (and former President) William Howard Taft, and governors of Alabama and several other states.

Battey also issued a series of earlier portraits which he titled "Our Master Minds." The series included Booker T. Washington, Paul

Battey's pictorialist portrait of Robert Russa Moton, who succeeded Booker T. Washington as Tuskegee's president.

Laurence Dunbar, Frederick Douglass, John M. Langston, a lawyer and educator, and Blanche K. Bruce, the first African American to be elected to a full term in the U.S. Senate.

And Battey continued to produce photographs to be used as cover illustrations for *The Crisis*. His work also appeared on the covers of *The Tuskegee Student* and *Opportunity*, "a journal of Negro life," as it described itself, which began publication in 1923. In a letter to the editor, Battey welcomed the new magazine, saying that

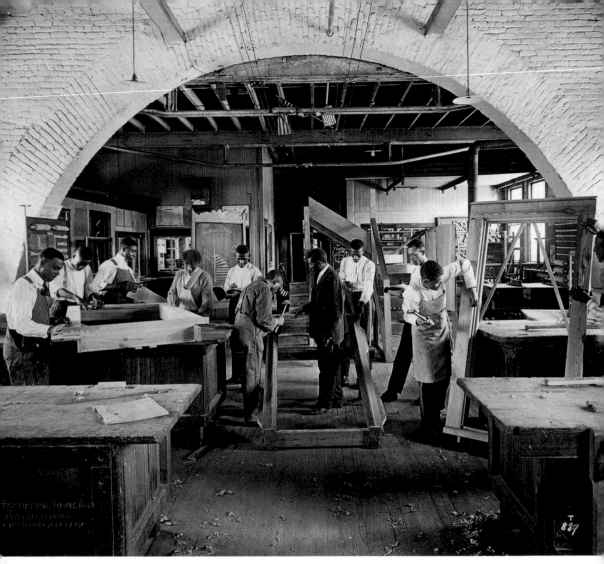

Busy students in the carpentry shop at Tuskegee.

he hoped the publication would continue to publish inspirational pictures that would express "the true beauty of the Negro's own individuality . . ."

Battey also spent his years at Tuskegee documenting student life, chiefly by photographing classrooms and workshops. Boys were pic-

tured in the machine shop and carpenter shop, the printing shop
and shoe-making shop. He photographed student firemen in the
boiler room at the school's heating plant. Girls were pictured in
mattress-making and curtain-making classes, and he photographed
their nursing classes. Almost without exception, these photographs
stress the students' dedication to their craft and the sense of pride
they felt.

Members of the girls' gymnastics class at Tuskegee are earnest and absorbed in this
Battey photograph.

During his years at Tuskegee, Battey continued to enter his pho-
tographs in exhibitions both in this country and abroad. On several
occasions, his work was judged to be of prize-winning caliber. *The
Tuskegee Messenger* described him as "an artistic photographer of the
first rank."

Battey continued working at Tuskegee until his death in 1927 at
the age of fifty-four. In his years there, Battey generated a truly
significant body of work depicting African Americans. But Battey
is probably best remembered not so much for what he photo-
graphed but for the artistic nature of much of his work, for his
ability to use his camera to evoke feelings of dignity, sympathy, and
pathos.

SIX

Addison Scurlock

On sunny Easter Sunday, 1939, an enthusiastic crowd of 75,000, about half of them African Americans, gathered in a great mass at the base of the Lincoln Memorial in Washington and watched as Marian Anderson, one of the great singers of the world, stepped to the cluster of microphones to begin what was to be the most memorable concert of her long career. She started with "America" and the familiar lines, "My country 'tis of thee, sweet land of liberty," then sang Schubert's "Ave Maria" and several other selections, and ended with Florence Price's "My Soul Is Anchored in the Lord." Millions listened on radio.

When Ms. Anderson had finished, the crowd cheered and applauded. Then a crush of well-wishers surged forward and attempted to mount the marble stairs to congratulate Marian

Marian Anderson and the huge throng that welcomed her at the Lincoln Memorial on Easter Sunday, 1939.

Anderson, threatening to mob her. Police had to hurry her back inside the Memorial where the towering figure of Abraham Lincoln looks down.

The excitement of the day is easy to understand. Not long before, the Daughters of the American Revolution had refused to permit Marian Anderson, an African American, to use Constitution Hall in Washington for a concert. Harold Ickes, Secretary of the Interior, responded by inviting Ms. Anderson to sing from the steps of the Lincoln Memorial on Easter Sunday in what has since been hailed as a smashing victory over segregation.

Addison Scurlock, one of the leading photographers of the day, was there that afternoon, wielding his boxy Speed Graphic. As Ms. Anderson began to sing, Scurlock set the camera's aperture to admit just the right amount of light, turned a metal knob at the front, focusing, then carefully composed his picture before pressing the shutter button. More than fifty years later, Robert Scurlock, Addison's oldest son, would still be getting requests for the photograph his father made of that historic moment.

The photograph of Marian Anderson at the Lincoln Memorial is one of the many thousands of pictures taken by Addison Scurlock. A slim, easygoing man, Scurlock opened his studio in Washington in 1911. In the half century that followed, he photographed the faces and institutions important to Washington's black community, and documented key events. His two sons, Robert and George, joined him in the business in the 1930s.

Addison Scurlock was "ever present at school and church ceremonies to capture on film Washington's and the nation's premier black community in its life and work," Dianne Wright, a historian at the Banneker-Douglass Museum in Annapolis, once wrote. "He ushered its politicians, statesmen, intellectuals, educators, and entertainers into his studio. He documented the story of African Americans in a community which cared for, educated, depended

on, and promoted its own. The results . . . are a treasury of black images that would have certainly been lost in time were it not for the Scurlocks and their cameras.''

Addison Scurlock was born on June 18, 1883, in Fayetteville, North Carolina. In 1900, after he had graduated from high school, the family moved to Washington, D.C. Addison's father, George Clay Scurlock, was a politician in North Carolina and had run unsuccessfully for a seat in the state senate. In Washington, he worked as a messenger for the Treasury Department. While working, hestudied law. After he completed his studies and had passed the bar examination, he opened a law firm on U Street in Washington.

Young Addison Scurlock arrived in Washington with the ambition of becoming a photographer. To learn the trade, Scurlock apprenticed himself to Moses P. Rice, a well-known Washington photographer. At the Rice studios, Scurlock learned the basics of portrait photography, how to handle the heavy and cumbersome view cameras of the day, which had to be mounted on tripods. Since there were no flashbulbs or electronic flash in those days, Scurlock had to learn to use what light was available or explosive flash powder.

He also became skilled in laboratory work, mixing his own chemicals to develop and print. Until the 1940s, the solutions necessary for photographic processing had to be mixed by hand from individual chemicals. Scurlock learned how to prepare developer in various strengths to produce images in a wide range of tones and contrasts, each suitable for a special mood or situation. In time, he acquired a complete understanding of the photographic process.

Beginning in 1904, Scurlock started serving his own customers,

working out of his parents' home. He became the official photographer for Washington's Howard University, and as such photographed students, the faculty, and every aspect of campus life. In 1911, Scurlock opened a studio on U Street in Washington. SCURLOCK STUDIOS—FINE PHOTOGRAPHY said a sign that hung out front.

At the time, Washington was a segregated city. A "separate but equal" doctrine prevailed in the nation's capital—as it did in every Southern state. On trains and other forms of public transportation, in schools, churches, hotels, restaurants, theaters, hospitals, and other public places, the races were segregated.

With African Americans barred from joining most labor unions and discouraged in their efforts to participate in white-owned businesses, many sought to go into business for themselves. John Hope, a professor at Atlanta University, speaking at the Fourth Atlanta University Conference in 1898, called upon blacks to escape the wage-earning class and become their own employers. The conference passed resolutions declaring that "Negroes ought to enter into business life in increasing numbers" and that "the mass of Negroes must learn to patronize business enterprises conducted by their own race . . ."

Booker T. Washington, the noted educator and founder of Tuskegee Institute, also encouraged black-owned businesses. He organized the National Negro Business League which, by 1907, had 320 local chapters. By the early 1900s, blacks operated businesses of all types—grocery stores and variety stores, restaurants and drugstores, bakeries and tailor shops. There were black-owned and black-operated shirt factories, carpet factories, department stores, and lumber mills.

The city of Washington boasted a thriving black community of churches, schools, and businesses, and a wide range of African-

Scurlock photographed the students, faculty, and events at Washington's Howard University for more than half a century. He pictured zoologist Dr. Ernest Just pondering an electrical experiment.

American cultural institutions. The city's "colored" public schools had a reputation for being highly competitive and the best then available to blacks. Black intellectual life in Washington was bolstered by the presence of Howard University, the only University open to a substantial number of black men and women. Howard's professional and graduate schools trained nearly half of the nation's black physicians and more than 90 percent of all black lawyers.

Addison Scurlock was a central figure in this world. Not only was he present at such events as high school graduations and church picnics, he began photographing Washington's black educators and entertainers, its politicians and intellectuals. "First and foremost, he was really a gentleman," wrote Dianne Wright of the Banneker-Douglass Museum in Annapolis where a major show of Scurlock's photographs was presented in 1991. "People trusted him. He was allowed in all their homes, and he entertained people in his home. He didn't need a calling card. He was accepted into Washington society and taken seriously," says Wright, "because of his skill, his talent, and his personality . . ."

Portrait photography was Addison Scurlock's speciality. Each one had a unique quality, what came to be known as the Scurlock "look"—a portrait in which there were no unsightly shadows, the light playing evenly across the features of the subject. "My father knew how to place the lights so they were just right," said Robert Scurlock.

Once a person's image was captured on film, the negative was carefully retouched. A facial blemish or crow's feet at the corners of the eyes might be removed. "The retoucher might even straighten a nose a little, or straighten a lip," said Robert Scurlock. "My father wanted each person to look his or her best."

But there is more to the Scurlock "look" than technical excellence. Jane Freundel Levey, editor of *Washington History* magazine, in an article she wrote about the Scurlock family, said: "Perhaps the most distinctive hallmark of the Scurlock photography is the dignity, the uplifting quality of the demeanor of every person." Scurlock, in his photographs, said Levey, "clearly saw each subject [as being] above the ordinary."

Scurlock's mastery in lighting a portrait is apparent in this photograph of Dr. Anna Cooper, an educator, author, reformer, and human rights advocate.

Little wonder that so many thousands of Washingtonians made their way to Scurlock's studio to have their images recorded—husbands, wives, and their children, businessmen, civic leaders, lawyers, doctors, educators, clergymen, and literary figures.

Besides studio portraits, Scurlock also mastered the use of the panorama camera, which produces a clearly focused image of very large groups, literally hundreds of people. This enabled Scurlock to photograph conventions and banquets, school graduations and fraternal organizations, and marching bands. Said Robert Scurlock, "There are probably very few homes in the black population of the Washington area without a Scurlock."

To illuminate large interior spaces, such as a ballroom or convention hall, in those days before flashbulbs or electronic flash, Scurlock had to rely on flash powder. This involved burning high-intensity magnesium powder for a second or two, while the exposure was made. It was a tricky business.

Scurlock made the photograph of a formal dance in the ballroom of the Whitelaw Hotel with a large-view camera from a balcony position and illuminated the scene with flash powder. Robert Scurlock pointed out that despite the lack of control, his father was able to evenly light the photograph from one edge to the other and provide sharp detail from foreground to background.

"And with flash powder," said Robert Scurlock, "you couldn't shoot over and over; you got only one chance. After the first try, the room was so filled with smoke from the explosion of the powder, it wasn't possible to attempt to photograph a second time."

Of the many thousands of photographs that Scurlock made, his portraits are the most valued. They are also the most reprinted, particularly those of notable Americans. These include the portraits of

Scurlock photographed Booker T. Washington at a private home, not his studio, using flash powder and a glass negative.

Booker T. Washington; educator Mary McLeod Bethune, founder of what is now Bethune-Cookman College; author, educator, and political leader W.E.B. DuBois; physician and researcher Charles R. Drew; poet Paul Laurence Dunbar; educator Mary Church Terrell; engineer Archie Alexander; opera singer Madame Lillian Evanti; historian John Hope Franklin; poet Sterling Brown; plus many others.

"In his era," Robert Scurlock once said, referring to his father, "he was an artisan, and people weren't in a hurry. Nowadays, in the era of the fast turnaround, everybody wants to know how *fast* you can do it. Nobody asks how *good* you can do it."

Addison and his wife, Mamie, lived only a few blocks from the studio. During the 1930s, their two sons, Robert and George, began working at the studio, running errands and helping out in the dark-room. Robert demonstrated a special skill as a photo retoucher. After Robert and George had graduated from Howard University, they joined their father on a full-time basis.

At the time, the Scurlock Studio was also functioning as a news service, supplying African-American newspapers with photographs of major events. The *Baltimore Afro-American*, *Chicago Defender*, *Pittsburgh Courier*, and the *Amsterdam News* in New York were among

The Phyllis Wheatley YWCA established Camp Clarissa Scott at Highland Beach on the western shore of Chesapeake Bay in 1931. Not long after, this group of young Washingtonians happily posed for Scurlock.

In his group photographs, such as this ballroom scene at Washington's Whitelaw Hotel, Scurlock, using flash powder, was able to light the photograph evenly from top to bottom and get every face in sharp focus.

the Studio's clients. "In the 1930s and 40s, there were few sources for black news," Robert Scurlock once recalled. "We filled the gap. We covered things just like the Associated Press. We'd shoot the pictures, caption them, and send them out. If they used a picture, they paid us, and if not, they'd return it. We didn't get many returned."

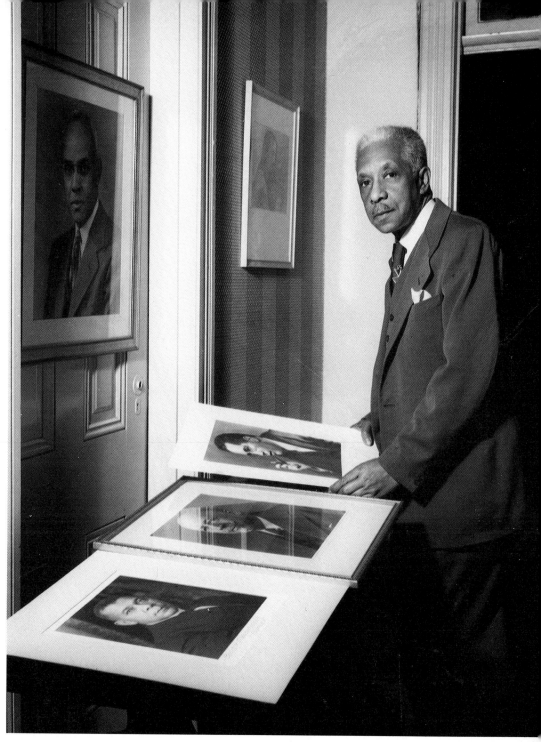

Addison Scurlock poses with three of his most famous portraits; from left, Booker T. Washington, W.E.B. DuBois, and Professor Sterling Brown of Howard University.

The news service phase of the Scurlock operation appealed to Robert. His father assigned him to take many of the news photographs they supplied to their client newspapers.

The Scurlocks didn't overlook the movies. During the 1930s, they also began a newsreel service, providing film footage on African Americans for the Lichtman chain of Washington theaters.

By the early 1940s, both George and Robert Scurlock were playing important roles in the family business. Robert served for four years in the Army Air Force during World War II. His tour of duty took him to Italy. During his free time, he often photographed the Italian countryside. George did not pass the Army physical exam and was able to keep active in the family business. He concentrated on nonportrait assignments, allowing Addison to do what he did best. After the war ended and Robert was discharged, he returned home and rejoined the family firm.

In 1948, George and Robert founded the Capital School of Photography, where a good number of ex-soldiers learned basic photographic skills. One of their students was young Jacqueline Bouvier, who was sent to the Scurlocks' school by the *Washington Times-Herald*, her employer at the time. Bouvier had been hired to produce an inquiring photographer's column. She met her future husband, Senator John F. Kennedy, while on assignment for the paper.

Robert Scurlock opened Custom Craft Studios in 1952 to concentrate on the processing of color photographs. Not only did he carry out assignments for local businesses and departments of the government, but he found time to cover current events—in color —for such magazines as *Ebony*, *Our World*, *Life*, and *Look*.

Addison Scurlock died in 1964 at the age of eighty-one. Robert and George took over the family enterprise. After the Scurlock

Studio on U Street was torn down in 1983, Robert continued to operate the family business out of his Custom Craft Studio.

Long before his passing, Addison Scurlock had become a pre-eminent figure in Washington, respected as both an artist and businessman. He also had come to be revered as the one who had recorded with honesty and sensitivity the story of African Americans in the nation's capital during a somber chapter in American history.

Stump and Stello, a famous vaudeville team, posed for this publicity photograph at the Scurlock Studio.

SOURCES USED THIS BOOK

Books

Baldwin, Gordon. *Looking at Photographs, a Guide to Technical Terms*. Malibu, California: J. Paul Getty Museum, 1991.

Ball, James P. *Ball's Splendid Mammoth Tour of the United States*. Achilles Pugh. Cincinnati: 1855.

de Abajian, James T. *Blacks in Selected Newspapers, Censuses, and Other Sources; An Index to Names and Subjects*. Boston: G. K. Hall, 1974.

Franklin, John Hope and Moss, Alfred A. *From Slavery to Freedom: A History of Negro Americans*. Sixth Edition. New York: Alfred A. Knopf, 1988.

Harlan, Louis R. *Booker T. Washington, The Making of a Black Leader*. New York: Oxford University Press, 1975.

Harlan, Louis R. *Booker T. Washington, The Wizard of Tuskegee*. New York: Oxford University Press, 1983.

Harlem Heyday: The Photography of James Van Der Zee. New York: Studio Museum in Harlem, 1982.

Harmon Foundation. *Negro Artists: An Illustrated Review of Their Achievements.* New York: International House, 1935.

McCulloch, Lou W. *Card Photographs, A Guide to Their History and Value.* Exton, Pennsylvania: Schiffer Publishing Co., 1981.

McGhee, Reginald (ed.). *The World of James Van Der Zee: A Visual Record of Black Americans.* New York: Grove Press, 1969.

Moutoussamy-Ashe, Jeanne. *Viewfinders: Black Women Photographers.* New York: Dodd, Mead & Co., 1986.

Newhall, Beaumont. *The History of Photography.* New York: Museum of Modern Art, 1982.

Pfister, Harold Francis. *Facing the Light: Historic American Portrait Daguerreotypes.* Washington, D.C.: National Portrait Gallery by Smithsonian Institution Press, 1978.

Ploski, Harry A. and Williams, James. *The Negro Almanac: A Reference Work on the African-American.* Fifth Edition. Detroit: Gale Research, 1980.

Rinhart, Floyd and Rinhart, Marion. *The American Daguerreotype.* Athens, Georgia: The University of Georgia Press, 1981.

Sandweiss, Martha A. (ed.). *Photography in Nineteenth Century America.* Fort Worth, Texas: Amon Carter Museum, 1991.

Simmons, W. J. *Men of Mark: Eminent, Progressive and Rising.* Cleveland, Ohio: Revel, 1887.

Taft, Robert. *Photography and the American Scene, A Social History, 1839–1889.* New York, Macmillan, 1938.

Tractenberg, Alan. *Reading American Photographs.* New York: Hill & Wang, 1989.

Welling, William. *Collectors' Guide to Nineteenth Century Photographs.* New York: Macmillan, 1976.

Welling, William. *Photography in America, The Formative Years, 1839–1900.* University of Mexico Press, 1987.

Willis, Deborah. *Black Photographers, 1840–1940; A Bio-Bibliography.* New York: Garland Publishing Co., 1985.

Willis, Deborah. *An Illustrated Bio-Bibliography of Black Photographers, 1940–1980.* New York: Garland Publishing Co., 1989.

Willis, Deborah (ed.). *J. P. Ball, Daguerrean and Studio Photographer.* New York: Garland Publishing Co., 1993.

Newspapers, Magazines, and other Periodicals

"East Saginaw, Something of the City and Those of the Race There." *The Cleveland Gazette,* August 20, 1887.

Jezierski, John V. "Photographing the Lumber Boom, The Goodridge Brothers of Saginaw, Michigan (1863–1922)." *Michigan History.* November/December, 1980.

Journal of Negro History, April, 1925, pp. 286–297. Letter from Augustus Washington.

Lang, William L. "The Nearly Forgotten Blacks on Last Chance Gulch, 1900–1912." *Pacific Northwest Quarterly,* April, 1979.

Levey, Jane Freundel. "The Scurlock Studio." *Washington History,* Spring, 1989.

Lloyd, Edith M. "This Negro Butler Has Become Famous as a Photographer." *American Magazine,* March, 1925.

"Mr. Battey Passes." *The Tuskegee Messenger,* March 12–16, 1927.

Myers, Rex C. "Montana's Negro Newspapers, 1894–1911." *Montana Journalism Review,* No. 16, 1973.

"The New York Expedition for Liberia." *Frederick Douglass' Paper.* November 25, 1853.

"One of Washington's Best Studios Is Negro Owned." *The Tuskegee Messenger,* January 31, 1931.

Perl, Peter. "The Scurlock Look." *The Washington Post Magazine*, December 2, 1990.

"Throng Honors Marian Anderson at Lincoln Memorial." *The New York Times*, April 10, 1939.

White, David O. "Augustus Washington, Black Daguerreotypist of Hartford." *Bulletin of the Connecticut Historical Society*, January, 1974.

White, David O. "Hartford's African Schools, 1830–1868." *Bulletin of the Connecticut Historical Society*, April, 1974.

Exhibition Catalogs

A Century of Black Photographers, 1840–1960. Valencia Hollins Coar (ed.). Providence, R.I.: Museum of Art, Rhode Island School of Design, 1983.

Crawford, Joe (ed.). *Black Photographers Annual.* Vol. 1. Brooklyn: Black Photographers Annual, Inc., 1976.

Crawford, Joe (ed.), *Black Photographers Annual*, Vol. 3. Brooklyn: Another View, Inc., 1980.

Crawford, Joe (ed.). *Black Photographers Annual*, Vol. 4. Brooklyn: Another View, Inc., 1980.

The Historic Photographs of Addison N. Scurlock. Washington, D.C.: The Corcoran Gallery of Art, 1976.

INDEX